Praise for *Revolutionary Women: A Book of Stencils*

What you hold in your hands is a lethal weapon. *Revolutionary Women: A Book of Stencils* is a threat to the status quo and a dangerous wake-up call to every person who has ever dared to think for themselves. These women herald in the voices of dissent, the movers and shakers for social change. Their history and hardship will inspire you to dismantle the shackles of cynicism and join forces with a global insurgency for freedom. The question remains . . . do you have the courage to join them or will you buckle under the weight of our cultural apathy? Will you rise up and fight for what you believe in, honoring the spirit of those who've fought before you, or will you cower with fear? I believe the words and art in this book have the power to mobilize a revolution. Rise up and let's join them now!

 —Wendy-O Matik, author of *Redefining Our Relationships: Guidelines for Responsible Open Relationships*

I greatly admire the kaupapa of the authors and of course, the celebrated women and work within the book. I am always happy to share my enthusiasm for strong women expressing themselves, empowering others and making the world a stereo place to live in. I am from a long line of diverse women who died and fought to see I could speak my mind, and I don't take their efforts lightly. I see the plight and power of women in daily life, in my own world, in history and in this book as one of the strongest forces known on earth. Everyday it's enough to motivate me to be a stronger artist and a better person.

 —Coco Solid, musician

The beauty and simplicity of message is stark in this zine. It is lovingly earnest with its handcrafted cut and pastes. The snippets are well-worded, the quotes cleverly chosen. The silhouettes of fearless females are striking. Overwhelmingly, one is left with a sense of the near-universal absence of images of revolutionary women. From now on, every time I see a Che Guevara portrait, I will wonder about his many unheralded and invisible sisters.

 —Karlo Mila, author of *Dream Fish Floating*

What an amazing, creative way to magnify, illuminate the courage of thirty Sheroes whose courage, leadership, and character is symbolic of the many unsung Women Sheroes of past and present. They continue to be held in high esteem as inspiration to us all at this very moment in the on going struggles for basic human rights.

 —Emory Douglas, artist, former Black Panther Party Minister of Culture

Knowing our feminist history gives us strength. *Revolutionary Women: A Book of Stencils* not only reclaims icons and agitators to nourish our collective and political imaginations, but passes on some of do-it-yourself stencil art. Use this incendiary word, and honor women who made change happ came before.

 —Red Chidgey, feminist historian, www.

REVOLUT

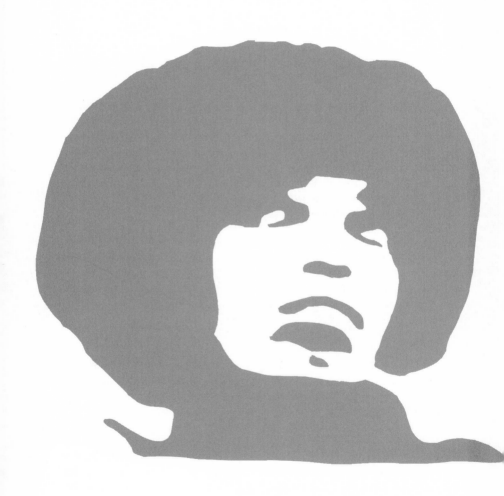

NARY
WOMEN

A BOOK OF STENCILS

Queen of the Neighbourhood

PM Press
2010

Revolutionary Women: A Book of Stencils
Queen of the Neighbourhood

Revolutionary Women: A Book of Stencils

Creative Commons Attribution-NonCommercial 3.0
2010, Queen of the Neighbourhood Collective & PM Press

ISBN: 978-1-60486-200-3
LCCN: 2010927795

Cover and inside design: Josh MacPhee/Justseeds.org

PM PRESS
PO Box 23912
Oakland CA 94623
510-658-3906
www.pmpress.org

First printing
Printed in the United States on recycled paper

CONTENTS

PREFACE

This project started off as a zine made in-house at Cherry Bomb Comics, a feminist zine store in Auckland, New Zealand, in 2005.

The zine slipped out of New Zealand and, like an infection, gradually took over the world and spread feminist fervor. I got word from people in Europe, North America, Australia, and Japan who were distro-ing it, adapting it, creating workshops based around it, and just generally feeling inspired by the stories of the amazing women in it.

When I was approached to expand the zine into an actual book, I was hesitant, because the project is so deeply a zine project: anticopyright, infinitely swappable, and propagated via the fluidity of human interaction. When writing zines you don't have to make any pretence to the objective, you can write "fuck" and ooze bias and unashamedly rip your research off anything you can find on the subject. A book is a slower, more meticulous process, in some ways more underhanded, emanating bias through carefully chosen verbs rather than outlandish adjectives.

However, I became convinced that a properly published book would reach a wider audience, and, as the project is partly a comment on pop culture aiming to resaturate our collective image bank by displacing the traditionally-held male revolutionary pin-ups with the lesser-known, lesser-remembered female ones, it seemed like a good idea. It was also a great impetus for the collective to sprout and continue the research I had really only just scratched the surface of in the original zine.

Tui Gordon
Queen of the Neighbourhood Collective

INTRODUCTION

I T CAME FROM THE SIMPLE QUESTION OF "WHO AND WHERE ARE OUR revolutionary women icons?" (or technically it began as "Who would you rather shag, Bob Marley or Che Guevara?" but the previous question rose out of the ashes of this one). It would be impossible to live in western culture and avoid coming into contact with an image of Bob or Che. Both are ubiquitous, household names, and symbols of rebellion. El Che, with that faraway look in his eyes, is synonymous in pop culture with revolution. However, when trying to come up with two examples of iconic, universally recognizable women for the same question "Who would you rather shag?" all I managed to think of were Marilyn Monroe and The Virgin Mary.

All the revolutionary icons and pin-ups are men: Che, Mao, Gandhi, Nelson Mandela, Malcolm X, Martin Luther King, Subcomandante Marcos, etc. A stencil of Che's face epitomises the glamour of revolutionary chic to the point at which it has become kitsch from overuse. The original photograph from which that famous image comes is not so extraordinary, but over time those black ink lines on a red background have evolved to be so loaded.

This book exposes that "Che" glamour by painting it onto thirty of the most well-known images of revolutionary women from mainstream and leftist media of the past 150 years. It aims to help resaturate our collective image bank with women as the instigators of revolutionary change—strong, idealistic, unafraid. It is also a celebration of some extremely brave women who have spent their lives fighting for what they believe in and rallying supporters in climates in which a woman's authority is never taken as seriously as a man's.

A few years ago I picked up a pamphlet at the 56a Infoshop in London about Louise Michel, having never heard of her before, and I remember being amazed by how fearless she was. I realised I had a preconceived idea that women were really repressed back in the old days; they were all either corset-wearing ladies who got married and rode side-saddle or working-class women who scrubbed floors 24/7 and had baby after baby with no

respite. But this is partly the myth of progress, and of course there have always been free-thinking women—outlaws full of fire, compassion, hopes, dreams, need for change, bravado, wealth of spirit, survival—who had no qualms about being socially unacceptable; who were articulate, smart, generous, driven.

The women in this book are all extremely different from one another: some would not welcome this eulogising of their egos; some might sit uncomfortably on their page, forced into a relationship with the other women in a kind of canon of revolutionaries, even though they may have very little in common with each other and have completely opposing viewpoints. I hope they can all taste the sweet satire of our icon-style brushing of them with Che Guevara glam; our massive nod to them; and the ways in which we are at the same time capping the knees of that cultural drive to make heroes when the real work is done by community, by people helping each other out.

Although the women in this book hail from vastly different backgrounds and circumstances, all of them are ardent about making change, and all are part of our collective history as people of the world. All are instrumental in exposing the flaws and injustices in our current paradigms and forcing humankind to question our assumptions about how things stand—between men and women, between rich and poor, between the powerful and the oppressed—and about humanity, life, and how we relate to each other and to the earth.

<p style="text-align:center">✳ ✳ ✳</p>

THE FIRST QUESTION THAT CAME UP WHEN APPROACHING THE TOPIC OF revolutionary women was "What makes a revolutionary?" There have been so many women over the ages who could be cast as "revolutionary," not only in direct action, but also in art, literature, music, science, medicine, etc. As Peggy Kornegger wrote, "Feminism is a many-headed monster which cannot be destroyed by singular decapitation." Revolution is about turning, about upheaval, about instigating a radical change in how we see things, in how we do things. Hence, the book hosts a combination of activists, anarchists, feminists, freedom fighters,

and visionaries involved in the struggle for total social upheaval and political change.

All the women in the book act and are driven to act by a deep sense of injustice and the need to address it or escape it. All of them are radical and extreme and nonconformist free-thinkers—people who see that the rules are there but who live outside them; outlaws, who are not necessarily choosing to live outside conventions, but who are just being unconventional, just being.

I remember being struck in Mexico by the huge letters "EZLN" burnt into the side of a hill outside the D.F., and the real sense that revolution was urgent and motivated not by intellectual ideals but by extreme, huge-scale poverty and injustice. To put it into that context, this meta-game we are playing with the image of revolution for a middle-class taste feels like just another commodity. But then again, EZLN affiliates sell handmade revolutionary merchandise to further the cause, and the imaging and propagation of revolutionary impulse can work to drive the momentum of the struggle.

In this image-based project, each of these women exists in photographic memory, in a visual space in which the images of their faces are already loaded with some kind of staunchness and have become branded in our culture with ideas; they have become icons, their images are read in society as summaries of the space and time in which they were immortalised. For example: Angela Davis is the political fugitive; Whina Cooper is the marcher for land rights; Phoolan Devi is the bandit; Emma Goldman is the anarchist; Rosa Luxemburg is the radical intellectual; Vera Zasulich is the nihilist; Vandana Shiva is the eco-feminist.

Some of the subjects in this book have instinctually acted radically, and some have spent some time writing down their ideas and philosophies. Sometimes their actions and philosophies, particularly as they have developed through their often quite public lives, have polarised people, and we are left wondering if they were amazing and radical or crazy and egocentric. With thinking far outside the mainstream, the women in this book are bound to be divisive characters, applauded by some and reviled by others. But they remain radical as icons in our culture; their life's work, actions or philosophical standpoints have been

captured in time by an image of them reproduced somewhere in our vast media machine.

Take the case of Leila Khaled: a Swiss Jewish girl I met was horrified that I would choose this Palestinian terrorist as an addition to the book. She saw her as a representation of the wrong side of a conflict and believed that the picture of her was basically pornography, particularly in an Islamic context; it is not a feminist image, a pretty girl with a big gun. I, however, find Leila's story fascinating, especially in the context of her becoming a pin-up. Young, beautiful, and demure, she was photographed whilst holding a rifle, captured in an inflammatory sexy picture plastered all over western media in the 1970s. Her image was so widely recognized that she underwent facial plastic surgery so that she could participate in a second aeroplane hijacking without being recognized. I feel that we are reclaiming the image, referencing it to a time and place. If it sits uncomfortably, this magnifies our satirical play with the idea of icons and hero-worship.

The case of Eva Rickard: As my original pick from Aotearoa/New Zealand media and my roots, Eva was an inspiring woman well known for her political feistiness and nonviolent re-sistance in stolen land occupations. I included an image and story of her in the original zine but when I approached her family, they were not keen to have her included in the book. Influenced by her own ideology, her family members are opposed to the propagation of her image, and particularly her moko (facial tattoo), for poten-tial capitalist gain and/or misappropriation by the public at large who have no concept of her culture and her struggle. The project went on hold for several months at that time as I revisited what was motivating the making of the book and examined how es-sentializing, exploitative, and colonising I was potentially being by using images of women who may not have wanted to be remem-bered in this way. Especially where indigenous struggle is on the line, is it culturally inappropriate to celebrate an individual woman for her feistiness whilst her life's work is submerged in meaning-less hero-worship iconography and romanticized in pop culture for the benefit of bored white women with cash to spend on a fancy art book? Who am I to tell a slanted story of her life and reproduce pictures of her face?

These questions are connected to our inclusion of women of color in general in the book. While there is a kind of a global sweep in the book, it is ultimately slanted heavily toward white Euro/North Americans, as the book derives its icons from the some of the most commonly generated images in western media. In western culture, images of women of color are far outnumbered by images of white women, and the portrayal of women of color is more likely to be victimized, demonized, or exoticized for the white male gaze. The lens of this book is also set on prescription white feminism by default, which is problematic when we are trying to divulge herstories of women who may have a completely different culture of feminism or belief structure around gender privilege in general. Also, in terms of icons, a black male icon might resonate more with a black woman than a white woman icon. The mixture of gender and race as integral to how we form our identities can depend on where the most pressure and the most prejudice is felt. In the end, I decided that it is still important to spread the information and the inspiration, and to write and draw skewed personal version of these stories and images which already inhabit a public space in our culture in books, newspapers, and the web, as this collection is thirty powerful stories and images that resonate with me and our collective of researchers and image-makers.

The case of Brigitte Mohnhaupt of the Red Army Faction: An icon but definitely not a heroine, Brigitte's urban guerilla activities were highly controversial. The members of RAF have been variously portrayed as terrorists, anti-imperialists, and confused youth, and they were responsible for hundreds of bombings and several murders. There are various levels of violence upheld by the revolutionary efforts of the women in this book. Some women included here are pacifists, some use violence to threaten. "The fear of a gun is a powerful thing," as Phoolan Devi has said. Some use violence to resist persecution, some use it to survive, some use it to make a really strong statement. The Che Guevara revolutionary style is definitely a militant one, and using that as a starting point for the project comes with the fear that the book is giving off a martial sexiness. Should we really be promoting violence as inspiring when most of our collective and readership live

in easy circumstances where we've never realistically had to face the question of armed struggle in our own lives?

Armed resistance has been part of the life experiences of many of the women in this book, despite the moral dilemma surrounding the use of violence in a specific context or at all. Ani Pachen put her Buddhist pacifism aside when her community's homes were being invaded. There are definitely situations in which it comes down, at the end, to force—whoever are bigger and stronger will get their way. Being smart or nonviolent is infinitely better but those efforts can still be crushed by force.

There are a plethora of forms of protest: sabotage, court cases, protest marches and sit-ins, guerilla warfare. The experiences of these thirty women show that, across time and place, some methods for social change and building revolution are the same everywhere: an emphasis on education, through schools or lecture tours or writing; grassroots organising; a healthy disrespect for the law and lawmakers; taking to the streets; looking after the needs of the poor, the homeless, the disenfranchised.

<p align="center">✳ ✳ ✳</p>

IN ONE RESPECT, THIS BOOK IS VERY BASIC FEMINISM: EARLY FEMINISM, CREATING visibility for women in a male-dominated area. Gender-based critique always fills a murky position in our current postfeminist climate in the West—women got the vote here in New Zealand in 1893; the 1970s "liberated" us and gave us equal pay and opportunities (or at least the framework for the possibility of equality). Growing up in the 1980s with the maxim "girls can do anything" has made my generation think we can, that we've won our equality, that feminism has done its job and is now outdated, which leaves us oblivious to the subtler forms of internalised sexism, as if in thirty years of feminism we've wiped out hundreds of years of patriarchy.

Given that we now read gender as not remotely binary, but rather as incorporating a vast array of trans and intersex genders, we know that pitting women against men is not a productive or even logical thing to do. So, if feminism is for equality between all genders, is it out of place to single out women

revolutionaries (trans-women included), when most of them have similar philosophies comparable to those of their male counterparts? Is it a reaction to the manarchists who don't believe gender privilege exists or is a valid topic of conversation? Since it is still the case that in most public situations, masculinity dominates and the feminine is undervalued, ignored or despised, this book's appraisal of vocal women still challenges the current climate of gender politics.

Lots of the women in this book (as well as I) are deeply into a much more revolutionary form of feminism than the simplistic positioning of women as equal to men on their terms. It involves total liberation from the patriarchal hegemonic system of the status quo and reimagining our lives in a totally new way. This means communalism as enacted by Harriet Tubman and the alter-globalism of Vandana Shiva—a world where the people survive, learn, and grow by sharing food, wealth, and information instead of buying into the capitalist paradigm of individualized entrepreneurship. I love the quote from Vandana Shiva about how we need to have abundant thinking: "Greed creates scarcity, and we're living in periods of scarcity. We need to have abundant thinking. We need to think generously to be able to generate generously."

The potentially patriarchal eulogising of egos in this book has been done selfconsciously, with the knowledge that the most successful of women's struggles come about from leaderless anarchist collectives, such as Mujeres Libres, rather than the deeds of one particular heroine. The background work for revolution, especially in our affluent, excessive western culture, which is dressed to be so stable and safe and middle-class, is in the small acts of humanity towards and between the people society marginalizes; in not allowing the rules and regulations and paradigms of that society to inform our lives; and in breaking down the patriarchal structures in our minds to find the freedom in the ruins to share and live with compassion and generosity. Feminism comes in all shapes and forms, and I hope that this book spans the gap from the gentle, simple, underlying revolutionary idea of generosity to the tough, dangerous, fiery urgency of revolution now!, and incorporates all of Emma Goldman's dancing and joyful humanity in between times.

At the base of all this nutting out of philosophical problems that the process of making this book has exposed, the main two points remain: to deliver a swift kick to the groin of deep-rooted patriarchal history and to provide pure enjoyment of staunch women and the ardor of revolution.

Tui Gordon
Queen of the Neighbourhood Collective

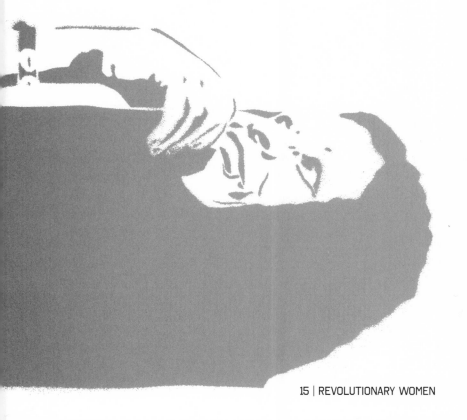

STENCILS-A-GO-GO

Queen of the Neighbourhood would like to invite you to cut and paint!

Stencils are beautiful and sneaky like an illegal printing press, with an awesome history of being used for disseminating fringe political ideas. One night out stencilling creates a street full of blossoming artwork as the sun comes up, a reclaiming of public space, a splash of humanity in the concrete jungle.

Stencils are fast and bold, the anticipation involved in the meticulous cutting process fully satisfied by the sweep of the spray paint.

The stencil images in this book are stripped down almost to abstraction: a simple tracing of the few most necessary lines to give the image life. The result is striking and immediate: a look, a stance, a facial expression.

The stencil side of this project transforms it from a storybook into a street-level resource; the interactivity of templates provide a starting point to expand it off the pages and into the world. Make patches, t-shirts, tea-towels, decorate your bedroom walls with a slick revolutionary aesthetic . . .

HARRIET TUBMAN
(CA. 1820–1913)

Harriet Tubman was an Underground Railroad conductor and strategist, education activist, Civil War nurse, and communalist. Born into slavery in Maryland, she was sold at age five as a house servant, repeatedly beaten, and later sold as a field worker. In her teens, her head was knocked so severely when she was blocking her owners from attacking another slave that it was permanently dented, and she suffered from narcolepsy for the rest of her life. She married a free man, John Tubman, but was under constant threat of being sold further south into malaria-ridden plantations (equivalent to a death sentence), so left him to escape north in 1849.

She reached "free" Philadelphia and met William Still who was a conductor on the Underground Railroad, an elaborate and secret series of houses, tunnels, and roads set up by abolitionists and former slaves. Harriet soon became involved in the Railroad, making nineteen trips to the south to kidnap and guide groups of slaves, including some of her family, to the north, and freedom. Nicknamed "Moses," she was always armed and threatened any escapee who showed frailty on the arduous trip north: "Dead niggers tell no tales." She became famous among slaves and infamous among slaveowners.

A year after she escaped slavery, the Fugitive Slave Act of 1850 permitted the recapture of escaped slaves in the north for auction in the south. Bounties for Harriet totalled $40,000, but she never lost a single "passenger." She thought on her feet and often used tricks and disguises to slip right under enemy noses.

She worked in the North during nine months of each year to fund these excursions. She helped found schools, even though she herself was illiterate; encouraged communal fostering of poor children; and worked to build a new African communalist culture in the North. She believed that personal wealth was wrong, and led by example.

The Civil War broke out in 1861, when Harriet was in her early forties. She lent her expertise to the Union Army as a

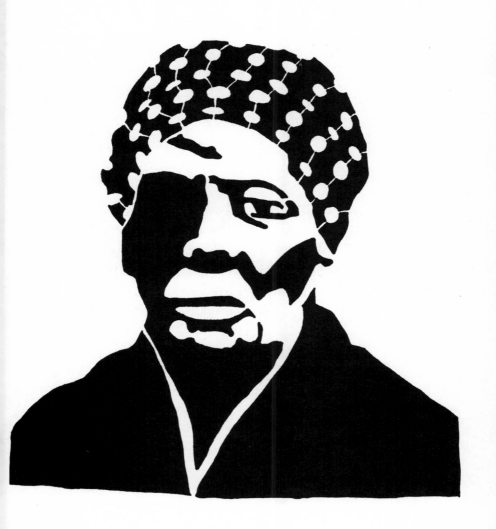

spy and a nurse. She used African medicine to nurse Black soldiers who were often sick due to their second-class status in the army. She started a women's laundry co-operative for the soldiers and later worked as a matron at a veterans' hospital. She also took part in a military campaign that resulted in the rescue of 756 slaves and destroyed millions of dollars' worth of enemy property.

After the war, she continued her involvement in social issues, including women's rights, always working at the grassroots level. In 1908, she established a home in Auburn, New York for elderly and indigent Blacks that later became known as the Harriet Tubman Home. She died aged approximately ninety-three.

"There's two things I've got a right to, and these are death and liberty. One or the other I mean to have. No one will take me back alive; I shall fight for my liberty, and when the time has come for us to go, the Lord will let them kill me."

L●UISE MICHEL
(1830–1905)

Louise Michel was an anarchist of the Paris Commune and a schoolteacher in France and New Caledonia. Daughter of a French servant and her aristocratic master, Louise was raised by her mother and her paternal grandparents. Once educated, she became a schoolteacher, though she refused to take the oath of allegiance to the Emperor and opened a private school.

In 1870, during the Franco-Prussian war, forty-year-old Louise Michel was arrested twice: once for having weapons, and once for demonstrating against a government-at-war. "I couldn't have organised any demonstration to speak to the government, because I no longer recognised that government."

Paris surrendered to the Prussians in 1871 and the French were allowed to elect a new government. During the ensuing bureaucratic mess, the people of Paris reclaimed their city for themselves. The result was "The Paris Commune," an anarchist society based on freedom and equality. Louise Michel was committed to the revolution. "It is the people who will deliver us from the men who have been corrupting us, and the people themselves will win their liberty."

Eventually, the Commune was usurped by the bourgeois authorities who took the city back by force. Louise turned herself in because they threatened to shoot her mother. With others from the Commune, she was forced to march through Paris in the middle of the night while those who refused were made to dig their own graves and then shot. About thirty thousand people were executed.

Louise was accused of trying to overthrow the government. Asked if she had anything to say in her defence, she replied: "If you let me live, I shall never stop crying for revenge and I shall avenge my brothers . . . If you are not cowards, kill me!"

She was sentenced to lifetime of exile in New Caledonia, where she was eventually allowed to work as a teacher for the colonists' children and for the indigenous Kanaky

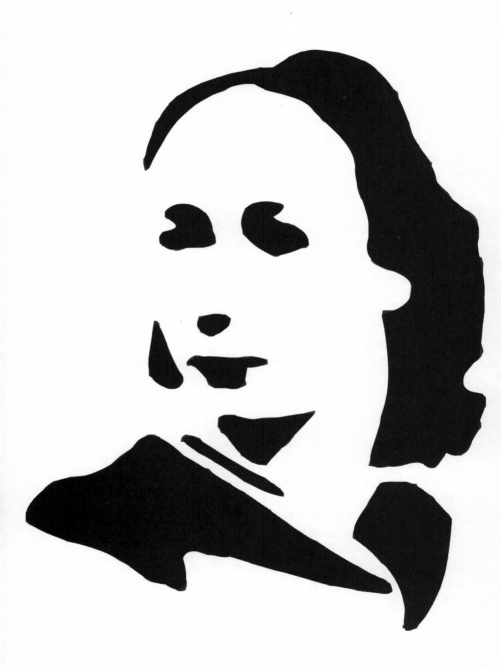

population. She supported the Kanaks' struggles against French colonialism and racism.

In 1880, the French Government gave amnesty to the prisoners of the Paris Commune and Louise returned home. She delivered public speeches, raised money for strike groups including women spinners, wrote articles on strike action, and worked to set up a soup kitchen for destitute exiled political prisoners who, like herself, were returning to Paris. She was often harangued by the authorities for her dissenting politics.

When sixty-eight anarchists (including Kropotkin, who had written an Anarchist Manifesto proclaiming "Bread for all, Knowledge for all, Work for all, Independence and Justice for all.") were sentenced to five years in jail in Lyon in 1883, Louise led a demonstration across Paris that involved some looting of bread in solidarity with those in prison. She was arrested and condemned to six years in prison. "It is not a question of breadcrumbs. What is at stake is the harvest of an entire world, a harvest necessary to the whole future human race, one without exploiters and without exploited." The following year, at age fifty-four, she was pardoned and freed.

In the last two decades of her life, Louise toured extensively in France, promoting anarchism. She was shot and wounded behind her ear during one public speech, but defended her assailant when he was on trial: "He was misled by an evil society."

After a trip to Algeria, she fell seriously ill in Marseilles. She died in 1905 and her funeral was attended by several thousand mourners.

"We revolutionaries aren't just chasing a scarlet flag. What we pursue is an awakening of liberty, old or new. It is the ancient Communes of France, it is 1703; it is June 1848; it is 1871. Most especially it is the next revolution which is advancing under this dawn."

MOTHER JONES

(CA. 1837–1930)

"**M**other" Jones was an American labor organizer, union activist, and teacher who became a legend in her own time. She was born Mary Harris in Cork, Ireland (though more likely in 1837 than on May Day 1830 as commonly celebrated). After the devastation of the potato famine, her father immigrated to North America and later sent for his family to join him. Mary arrived in Toronto, when she was in her mid-teens, learned dressmaking, and worked as a teacher in Michigan and Tennessee.

While living in Memphis, Mary met and married George Jones, an iron molder and active member of the International Iron Molders Union. The couple had four children. In 1867, a tragic yellow fever epidemic claimed the lives of Mary's husband and all of her children, after which Mary moved to Chicago at age thirty to start a new life as a dressmaker. There, another disaster struck when the 1871 Great Chicago Fire destroyed her shop and all her possessions.

Mary later claimed that it was after the fire that she turned to labor activism. By the mid-1880s, when she was in her late forties, she joined the Knights of Labor and in the 1890s agitated for the newly formed United Mine Workers (UMW).

She dedicated her life to organizing American workers (mostly coal workers) into unions and to offering support during strikes, including organizing the strikers' wives into "mop and broom brigades" to drive out scabs. She was a spellbinding public speaker and worked hard to educate the public about the appalling conditions of American workers. In 1903, Mother Jones famously led an interstate march of under-sixteen-year-old striking textile workers in order to force public's attention to the problem of child labor. She lived among the people with whom she worked, and said that her home was "Well, wherever there is a fight."

As a UMW activist, she rose to fame as "Mother Jones," the self-proclaimed "hell-raiser," denounced in the Senate as "the most dangerous woman in America" and "the grandmother of all agitators." This led Mother Jones to retort, "I hope to live long enough to be the great-grandmother of all agitators."

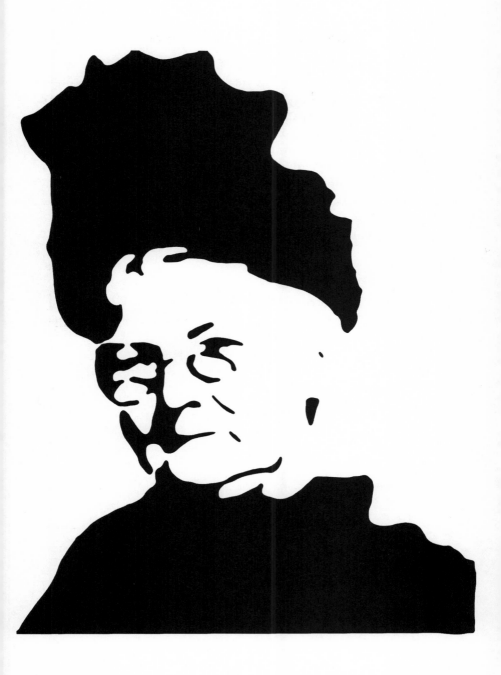

Mother Jones worked as a lecturer for the Socialist Party from 1904 to 1912 before returning to the UMW. In 1905, she participated in the founding of the International Workers of the World but subsequently remained aloof from the organization. In 1913, she was arrested while leading a protest march in West Virginia, convicted by a military court on trumped-up charges of murder, and sentenced to twenty years of imprisonment. The trial itself highlighted the terrible conditions in West Virginia's mines and led to a Senate inquiry in the matter as well as Mother Jones' release. The same year, she was arrested twice during a yearlong strike of mine workers in Colorado.

Mother Jones left the UMW in 1922, but continued to make public appearances as a speaker on labor issues into her nineties.

"Pray for the dead and fight like hell for the living."

VERA ZASULICH
(1849–1919)

Vera Zasulich was a Russian political activist and radical intellectual. She was born into a poor family in Mikhaylovka, Russia. Her father died when she was three years old and her mother, unable to cope, sent Vera to live with wealthier relatives.

Vera moved to St. Petersburg when she finished school, and worked as a clerk. She became involved in radical politics through the Nihilist movement revolutionary Sergi Nechayev. "I could imagine no greater pleasure than serving the revolution. I had dared only to dream of it, and yet now he was saying that he wanted to recruit me." She joined a weaving collective and conducted literacy classes for workers. Then, in 1876, twenty-seven-year-old Vera found work as a typesetter for an illegal printing press and joined the Land and Liberty group.

In the late 1870s, feelings against the highly repressive Tsarist regime were reaching boiling point. Nearly two hundred insurrectionists were imprisoned without proper trial. Bogolyubov, an acquaintance of Vera's, was sentenced to ten years of penal servitude simply for attending a demonstration. During an inspection of the increasingly unruly prisoners, the Chief of Police, General Trepov, ordered Bogolyubov to be flogged in front of other prisoners for wearing a hat at the wrong time. This caused a prison mutiny.

Vera decided to assassinate General Trepov. "Trepov and his entourage were looking at me, their hands occupied by papers and things, and I decided to do it earlier than I had planned . . . The revolver was in my hand. I pressed the trigger—a misfire. My heart missed a beat. Again I pressed. A shot, cries. Now they'll start beating me. This was next in the sequence of events I had thought through so many times."

Trepov survived. Vera was arrested and charged with attempted murder. She was given a fair trial by jury, as the authorities assumed the case was cut-and-dried—she had admitted to firing the shot, and there were plenty of witnesses. However, Vera's humble, dignified demeanour coupled with the defence's evidence of police brutality resulted in an acquittal.

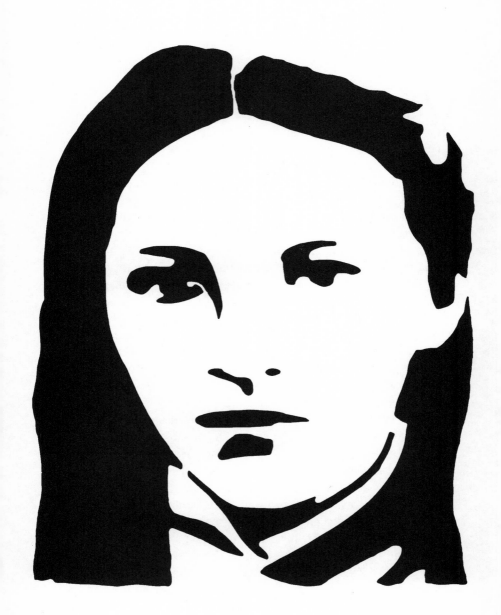

Police tried to re-arrest her outside the court, but the crowd rioted and allowed her to escape. Vera was forced into hiding and immigrated to Switzerland two years later. She became openly critical of the climate of terrorism that had in part been sparked by her assassination attempt on Trepov and that led to the assassination of Tsar Alexander II in 1881.

In 1883, at age thirty-four, she helped found the first Russian Marxist group and translated a number of Marx's works into Russian. Later, she became active in the Social Democratic Labour Party (SDLP) and served on the editorial board of *Iskra*. She wrote several Marxist-influenced articles on Russian strike actions and politics.

She returned to Russia for the 1905 Revolution, but her commitment to revolutionary politics waned with its failure. During World War I, Vera supported the war effort and opposed the Bolshevik Revolution. She remained an intellectual until her death in 1919.

"It was hard to starve during the summer but what will it be during the severe frost? What expectations have these intrepid fighters for the right to have, between the time of work and sleep, three hours of leisure 'as befits human beings'?"

LUCY PARSONS
(CA. 1853–1942)

Lucy Parsons was an American unionist, workers' rights activist, and dressmaker who endorsed violent direct action. She was born of African-American, Native American, and Mexican ancestry, probably in Texas and perhaps in slavery. Around 1870 she met Albert Parsons, who became her husband, although due to laws discouraging interracial marriage, the couple may never have legally married. They were forced to leave Texas in 1873 due to their relationship and political activism, and settled in Chicago.

Lucy worked as a self-employed dressmaker and gave birth to two children. Both she and Albert became members of the Knights of Labor and the Social Democratic Party. Later, Lucy helped found the Working Women's Union and, with Albert, helped organize the local section of the anarchist International Working People's Association.

She published frequently on labor and social issues and was a speaker of formidable talent—according to the Chicago police, "more dangerous than a thousand rioters." Enraged by social injustice, which she saw as caused by economic oppression of the majority by a wealthy minority, she supported violent direct action. Endorsing the slogan, "The land to the landless; the tools to the toilers; and the product to the producers," she concluded, "For without this right to the free use of these things, the pursuit of happiness, the enjoyment of liberty and life itself are hollow mockeries. Hence the employment of any and all means are justifiable in obtaining them, even to a forceable violent revolution."

In 1886, Lucy was deeply involved in the workers' struggle for the eight-hour day. During a meeting on May 3 at Haymarket Square, a bomb was thrown at police, leading to gunfire and the deaths of seven police officers and several civilians. Albert was among the anarchists tried for murder and sentenced to death, despite the utter lack of evidence of involvement. Lucy traveled widely, speaking about the case and demanding justice for her husband. This was to no avail; Albert Parsons and three

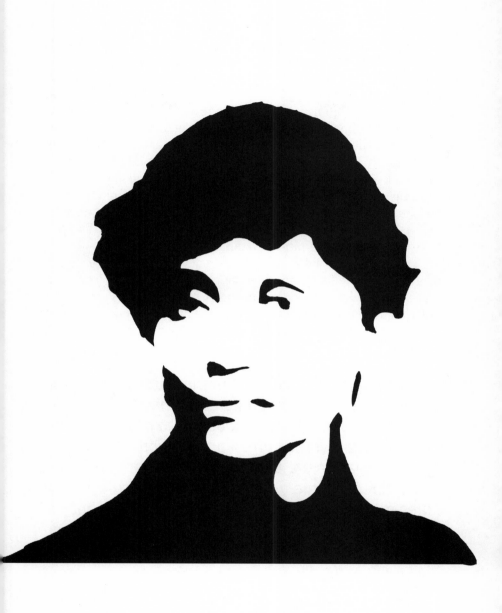

others were executed on November 11, 1897. Lucy was to uphold her husband's memory for the rest of her life.

Lucy continued to travel widely on speaking tours and to write, founding the journal *Freedom: A Revolutionary Anarchist-Communist Monthly* in 1891. She was among the founding members of the Industrial Workers of the World, advocating the idea of the sit-down strikes and sabotage as weapons in class struggle. Freedom of speech was a dominant theme in her work—she was frequently prevented from speaking herself—as was the defense of political prisoners. After the economic crashes of 1908–1909, she began to focus on hunger and unemployment issues. The "Hunger Demonstrations" she organized in Chicago in 1915 forced the government to confront unemployment.

In the postwar years, Lucy worked frequently with the Communist Party, and despite her failing eyesight continued her activism until the final months of her life. Lucy Parsons died in a house fire, and her ashes are buried at the monument for the "Haymarket Martyrs," who include her husband.

"The philosophy of anarchism is included in the word 'Liberty,' yet it is comprehensive enough to include all things else that are conductive to progress . . . No barriers whatever to human progression, to thoughts, or investigation are placed by anarchism; nothing is considered so true or so certain, that future discoveries may not prove it false; therefore, it has but one infallible, unchangeable motto, 'Freedom': Freedom to discover any truth, freedom to develop, to live naturally and fully."

"We are slaves of slaves. We are exploited more ruthlessly than men."

EMMA GOLDMAN
(1869–1940)

Emma Goldman was an author, free-thinker, and activist, and is considered the first anarcha-feminist. She was born in a Jewish ghetto in Russia, but her family moved to politically-charged St. Petersburg just after the assassination of Tsar Alexander II in 1881. Poverty forced Emma to leave school early and work in a factory and later a corset shop. When she was fifteen, her father tried to marry her off but she refused and eventually managed to convince him to let her immigrate to the United States with her sisters. There, she earned her living as a seamstress and married a fellow Russian immigrant whom she divorced ten months later.

Emma was drawn to anarchism by the Haymarket Square tragedy (the origins of May Day) in 1886 *(see section on Lucy Parsons)* and became active in anarchist circles after moving to New York. On her first speaking tour, she demanded the total overthrow of capitalism; after reading Kropotkin later, she developed her ideas to encompass the wider struggle for workers' rights.

In 1892, she and Alexander Berkman planned to assassinate Henry Clay Frick, a factory owner who had suppressed strikes with armed guards. The attempt failed and Alexander was sentenced to twenty-two years in prison.

Though Emma was not imprisoned at that time, she was a labeled troublemaker and the authorities regularly disrupted her lectures. She did go to prison several times for allegedly urging the unemployed to take bread "by force"; for distributing birth control literature; and for rallying against World War I and conscription. In 1919, she was stripped of her U.S. citizenship and deported along with other undesirable "Reds," including Alexander, to Russia.

Hoping to find a communist utopia in Russia, she was horrified to instead witness an increase in persecution and bureaucracy—the failings of the Russian Revolution. After immigrating to England in 1921, Emma wrote two works on her "Disillusionment in Russia": "Never before in all history has authority, government, the state, proved so inherently static, reactionary, and even counter-revolutionary."

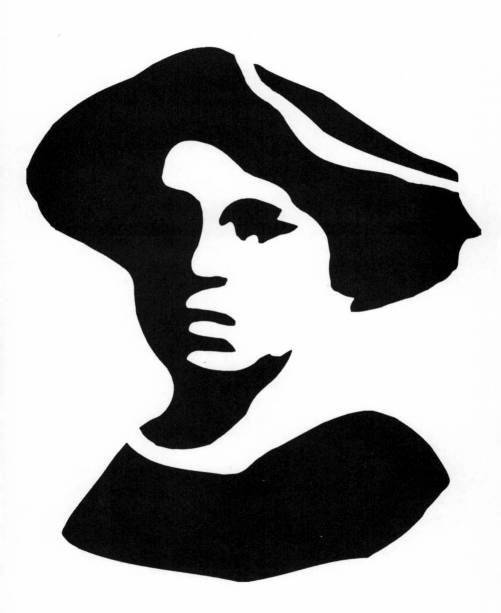

Her views were unpopular among Bolshevik-supporting radicals, and her lectures were poorly attended. In 1925, she was threatened with deportation but managed to get a British passport by marrying a supportive Welsh miner. Her new passport gave her the ability to travel abroad giving lecture tours in France, Canada, and, in 1934, even the United States.

In 1936, at the age of sixty-seven, Emma went to Spain to join in the Civil War cause. She told a rally of libertarian youth: "Your Revolution will destroy forever [the notion] that anarchism stands for chaos."

Emma Goldman wrote several important anarchist texts including *Anarchism and Other Essays* (1910), *The Social Significance of the Modern Drama* (1914), and *Living My Life* (1931). She wrote that a woman could affect change "first, by asserting herself as a personality and not as a sex commodity. Second, by refusing the right to anyone over her body; by refusing to bear children unless she wants them; by refusing to be a servant to God, the state, society, the husband, the family etc. . . . Only anarchist revolution and not the ballot will set woman free."

"[I]t is one thing to employ violence in combat as a means of defence. It is quite another thing to make a principle of terrorism, to institutionalise it, to assign it the most vital place in the social struggle. Such terrorism . . . becomes counter-revolutionary."

ROSA LUXEMBURG
(1871–1919)

R osa Luxemburg is one of the most important and well-remembered figures of the German radical socialist and antiwar movement prior to World War I. Her outspoken views that revolution should come from the masses rather than an elite group, and that the focus of the struggle should always be the overthrow of capitalism, placed her at odds with many other socialists. Many of her writings are now considered classic treatises.

She was born in Zamość, in Russian Poland. As a teenager, she helped to organize a general strike with the Polish proletariat party. The strike led to the execution of four party leaders, and Rosa fled to Switzerland where she continued her studies. There, she met other socialist revolutionaries and cofounded the paper *Sprawa Robotnicza* (The Workers' Cause). The newspaper strongly opposed the nationalist policies of the Polish Socialist Party, arguing that the focus of struggle should be the total overthrow of capitalism. Rosa and her associates felt that focusing on Polish independence would give the bourgeoisie more opportunity to oppress the workers. She and Leo Jogiches formed the Social Democratic Party of the Kingdom of Poland and Lithuania.

In 1898, Rosa gained German citizenship and moved to Berlin, joining the Social Democratic Party (SPD). She continued to oppose the idea of revisionist socialism and pushed for revolution. She believed that the best way to radicalise workers and achieve revolution was through a general strike.

Rosa eventually split with the German SPD, as its members refused to support her view that all European workers' parties should unite and organize a general strike to prevent the looming war. When war broke out and the SPD supported the imperial government in going to war, Rosa contemplated suicide, but chose instead to organize antiwar demonstrations and along with other activists, including Karl Liebknecht, formed the Spartakusbund (the Spartacus League). The group published its antiwar views in an illegal underground newspaper. As a consequence, Rosa and her allies were imprisoned for the majority of

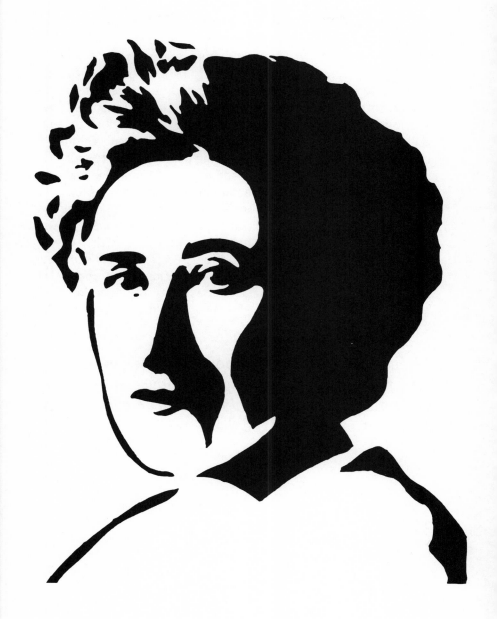

World War I. Her articles, including "The Russian Revolution," in which she openly critiqued Lenin and the antidemocratic tactics of the Bolsheviks, were smuggled out of prison and published.

She was released from prison in 1918 and co-founded the German Communist Party (KPD). Following the end of World War I, the KPD was in favour of a radical revolution, but parliamentary democracy was established. The SPD assumed power and formed the Weimar republic. In 1919, Rosa helped organize the Spartakist Rising, but the leader of the SPD and Germany's new chancellor called in the right-wing paramilitaries to crush the rebellion. A few days later, Rosa and Karl were kidnapped and murdered; Rosa's body was dumped in Berlin's Landwehr Canal.

Rosa Luxemburg is remembered for her firmness of belief, and her vast intellectual and rhetorical abilities. She viewed women's issues as being intertwined with those of the working class and felt that women would be free from their economic bondage to the Family once social revolution came about. Her most famous quote is in direct contrast with the direction communism took in East Germany following World War II:

"Freedom only for the supporters of the government, only for the members of a party—however numerous they may be—is no freedom at all. Freedom is always the freedom of the dissenter."

MARIE EQUI
(1872–1952)

D r. Marie Equi was an anarchist, a supporter of the women's suffrage movement, an illicit abortion provider, an activist fighting for working-class rights, and an open lesbian. Born in Massachusetts, United States, Marie Equi moved to The Dalles, Oregon, at the age of twenty-one with her friend Bess Holcomb, a teacher. The two lived together in what was described at the time as a "Boston marriage."

Infamously, Bess's employer, the Reverend O. D. Taylor refused to pay her what he had promised, so Marie declared she would publicly horsewhip him if he didn't pay up. True to her word, Marie waited outside for Taylor to emerge from the office where he worked, and then laid into him with a rawhide whip. Marie received support from the local community and the media, who admired her plucky spirit; the community raffled off the whip, raising the amount owed to Bess and bequeathing it to the women.

Marie moved to California to study medicine, and in 1903 became one of the first women to graduate with an M.D. She set up a practice attending to working-class women and their children, and through her work met Harriet Speckart, who worked as her assistant. The two began a relationship and eventually adopted a daughter, Mary.

Following the San Francisco earthquake in 1906, Marie organized a group of doctors and nurses to provide aid, and for this initiative received a special commendation from the United States Army.

Marie also became one of a group of doctors in Portland who provided abortions. She was active in providing access and information about birth control, forming a friendship with birth control activist Margaret Sanger. The women were arrested after an incident in which they tried to defend a group of men who were caught distributing a birth control pamphlet that Marie had helped Sanger write.

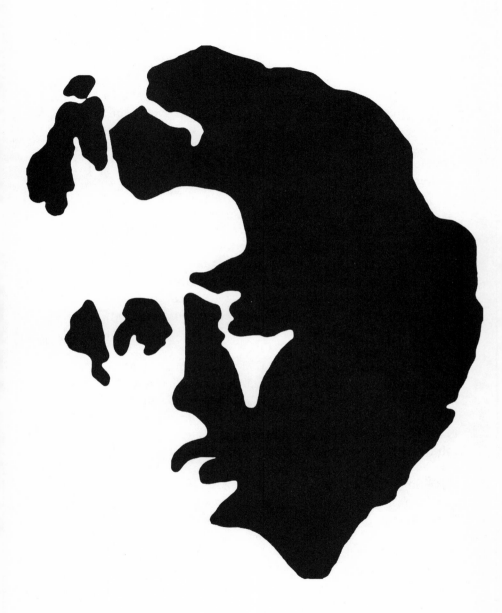

In 1913, Marie joined the women cherry sorters from the Oregon Packing Co. on the picket line. This strike was also supported by the Industrial Workers of the World (IWW, aka the Wobblies), a group which Marie later joined. Police were called in to clear the women away, and while Marie attended to a worker who had been injured, she was attacked by a police officer. The brutality she encountered during this strike led Marie to denounce capitalism altogether, and to become an anarchist. In 1916, she joined the American Union Against Militarism, and started a small riot at a war-preparedness rally when she unfurled a banner which read: "Prepare to die, workingmen, J.P. Morgan & Co. want preparedness for profit." This led to her arrest.

In 1918, Marie was accused of sedition due to an antiwar speech she made at an IWW conference. She was sentenced to three years in prison, serving a year and half in total. By all accounts, Marie was not an easy prisoner, bending the rules and making trouble just as she did when she was free.

Marie was released from prison, and began a relationship with Elizabeth Gurley Flynn, a leading activist in the IWW. In 1930, she had a heart attack at the age of fifty-eight, and was mainly bedridden for the rest of her life, except when she got up to join in the antiwar protests of the 1940s. She died in Portland.

"I'm going to speak when and where I wish. No man is going to stop me."

QIU JIN

(CH'IU CHIN)
(CA. 1875–1907)

Qiu Jin was a Chinese feminist, educationalist and martyred leader in a revolutionary uprising. Born into a scholarly family, she was the granddaughter of famously loyal and heavy-handed official of the Imperial Court, Zen Guo-Fan. Her parents ensured that she received an excellent literary education even though she was a girl. It is said that her mother gave up trying to teach her sewing and embroidery because Qiu Jin preferred archery, horseback riding, and reading martial arts novels.

When Qiu Jin was eighteen, she acquiesced to an arranged marriage. Her husband, Wang, moved them to Beijing, where the political climate was charged and chaotic after China's losing war with Japan (1894–1895), a series of peasant uprisings, corruption of the Manchu government, and the meddling of foreign powers.

To the distress of her conservative husband, Qiu learned swordfighting, drank wine, and wore western men's clothing in public. Her revolutionary feminist ideas made her a pioneer in the Chinese women's struggle; she established a girls' school, and campaigned against footbinding and sex slavery.

In 1904, at the age of twenty-nine, she left her fraught marriage and her two children in order to study in Japan. She experienced enormous societal pressure for her choices. "Our ideas are not the same," she told her husband. "It is as if we lived in the netherworld prison. I do not desire to live in a hell, nor do I wish you to be there. We will part." At the time, Japan was considered much more progressive than China, and provided a breeding ground for revolutionary ideas. Qiu Jin enrolled in the Girls' Practical School in Tokyo and helped revive the defunct All-Love Society, a women-only political group. She encouraged other Chinese women to sell their dowries and get educated in Japan. She began disseminating revolutionary writings into colloquial

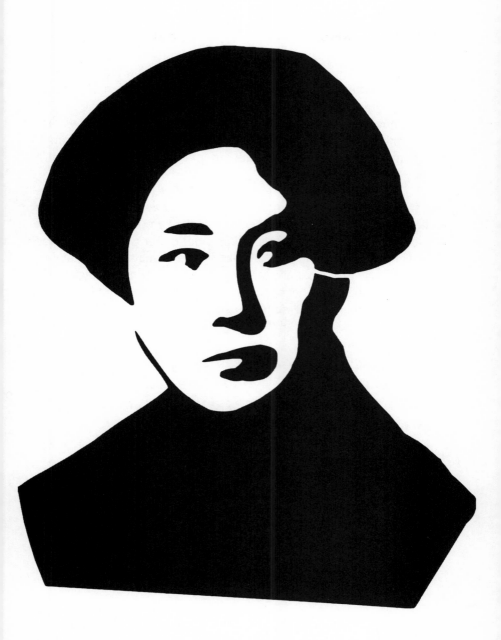

Chinese to spread the word to the less literate. Qiu also became the first woman member of Sun Yat-sen's Revolutionary Alliance.

In 1906, she returned to Chejiang in China. In addition to tending to her sick mother, she took up a teaching position under Xu Zihua at the Ta-t'ung College of Physical Culture and founded a student branch of the Revolutionary League. She later moved to Shanghai, worked in a clandestine explosives factory and founded a radical women-positive newspaper. Through underground networks, she built up an army which she led in a 1907 uprising in Shanghai.

The uprising, one of several of its kind, was unsuccessful. Qiu went briefly into hiding, but was eventually caught by the Imperial Police. She refused to speak even under torture, but two of her poems were presented as proof of her guilt and she was beheaded. In her own time, she was seen as a martyr—Sun Yat-sen oversaw her state reburial after the overthrow of the Qing dynasty in 1912. Xu Zihua wrote her epitaph, which was engraved on her tombstone by woman scholar (and Qiu´s probable lover) Wu Zhiying.

"Ah! slowly, slowly a thread of light is piercing the black darkness of our women's realm, which shut in on all sides, for four times one thousand years has existed until the present day."

"We women love our freedom
Raise a cup of wine to our efforts for freedom
May heaven bestow equality on men and women
We will rise in fight, yes! Drag ourselves up!"

NORA CONNOLLY O'BRIEN
(1893–1981)

Nora Connolly O'Brien was a labor unionist and an Irish republican and parliamentarian. She was born in Scotland, daughter of committed social activist James Connolly. In 1903, her family immigrated to the United States where she worked for a hatmaker, attended labour meetings with her father, and assisted him with his journal *The Harp*.

They moved to Belfast, Ireland, in 1910 and Nora worked in the mills and joined Fianna Éireann (the Republican Youth Movement) which taught military drills and the use of firearms. At that time, she also helped organize the Belfast branch of Cumann na mBan (The League of Revolutionary Women), through which she taught first aid. At the time, strikes and lockouts in the area were on the increase, as unions grew stronger and workers began to unite and stand up against appalling factory conditions. During the Linen Strike of 1913, Nora made her first public speech, addressing a rally at which her father was also speaking: "You [James Connolly] took me to meetings as your daughter, now I come to them myself, as a worker."

In 1914, James Connolly became the Commandant of the Citizen Army and began to shift the movement's focus to military struggle. Women had equal rights in the Citizen Army, and Nora recruited volunteers. "They came, their faces black with coal dust, some powdered with cement or grain, up from the ships, out from the dockyards, machine shops, factories, deserting carts, lorries, vans."

In Dublin for the Fianna Convention, Nora took part in the Howth gun-running operation, arranging for thousands of rifles to be stored overnight at the cottage of Constance Markievicz on their way to Belfast. Nora also assisted her father with a new paper, *The Worker's Republic*, which reached both workers and volunteers, expounding revolution.

In 1916, in preparation for the Easter Rising, Nora liaised with the American Irish, and helped activist Liam Mellows return to Ireland disguised as a priest after his escape from Reading

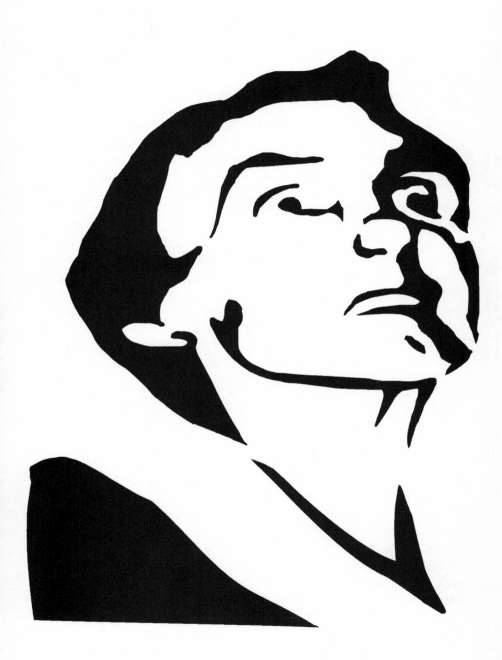

46 | NORA CONNOLLY O'BRIEN

jail. During the Rising, Nora was sent to Belfast to rally the volunteers and smuggle dispatches; as she was walking the fifty miles between Dundalk and Dublin because no trains were running, however, the rebels surrendered. The British soldiers had outnumbered them ten to one. Nora was devastated that she hadn't been able to reach the fighting in time. All of those who took part were jailed, including her father who was subsequently executed.

After a tour to America to speak about the Easter Rising, Nora was forbidden to re-enter Ireland, but managed to get through in disguise.

Nora worked for the Transport Union in Dublin and campaigned for Sinn Féin in the general election. She married Seamus O'Brien (also involved in the Nationalist struggle) in 1922. In 1923, she became Paymaster-General of the IRA and spent time imprisoned in Kilmainham and Mountjoy jails for her activism.

In 1926, Nora became a member of the Irish Senate and sat for three terms. She was politically active until the end of her life and published a book, *We Shall Rise Again*, just before her death at age eighty-eight.

"For many centuries, we in Ireland have had an unbroken tradition of each generation having an armed uprising against Britain. In my generation we had an armed uprising in 1916 with the proclamation of freedom of the Republic of Ireland . . . Here we are rising again, and if we go down, we'll rise again!"

LUCÍA SÁNCHEZ SAORNIL
(1897–1970)

Lucía Sánchez Saornil was a poet and feminist who worked for anarchism during the Spanish Civil War. She was born into a poor family in Madrid, Spain. Her mother died young and Lucía was raised by her father. She worked as a telephonist to fund her study at art school, where she started writing. She published her first poems in 1918 in *Los Quijotes*, an avant-garde poetry review, and also wrote lesbian erotica under a male pseudonym.

At the age of twenty, Lucía discovered anarchism and started writing revolutionary rather than experimental poetry. She realized that the Spanish Republic was a bourgeois farce, and became secretary of the National Confederation of Workers (CNT), one of the main anarchist parties in Spain at the time. She was vocal about the liberation of women and argued that equality of the sexes was as important as that of classes. Her doctrine that antisexism should start at home made her unpopular with some of her male contemporaries.

Together with Mercedes Comaposada and Amparo Poch, she helped found Mujeres Libres (Free Women) in 1936, and edited the *Mujeres Libres* magazine. Mujeres Libres was based on grassroots anarchist principles and promoted freedom for women from the shackles of patriarchal society and a strong D.I.Y (Do It Yourself) ethos. The organization had twenty thousand women affiliates who worked before and during the Spanish Civil War for the reality of anarchism that had spontaneously developed there.

In 1938, Lucía became secretary of the General Council of International Antifascist Solidarity (SIA) in a bid to stop the Fascists from taking over Spain. The same year, she moved to Valencia where she met América Barroso who became her life partner.

In 1939, the two women lived in exile in France, as their politics kept them in danger, but then fled back to Spain in 1941 under the threat of being sent to a German concentration camp for being lesbians. They lived together in Valencia until Lucía

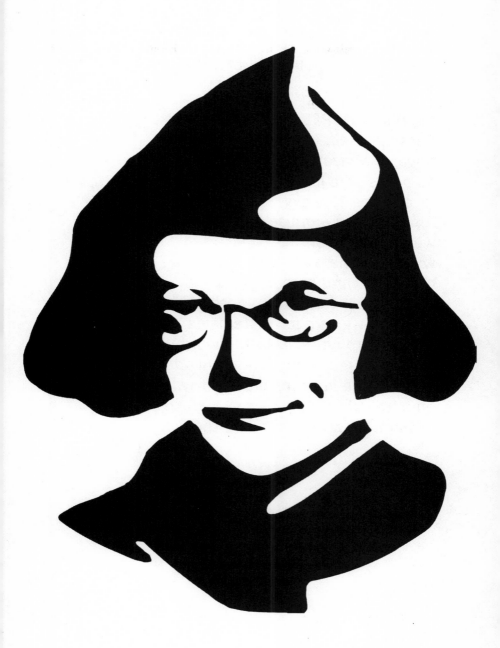

49 | LUCÍA SÁNCHEZ SAORNIL

died of cancer in 1970. América had the following epitaph written on her tombstone: "Pero . . . ¿es verdad que la esperanza ha muerto?" ("But . . . is it true that hope has died?")

MUJERES LIBRES
Fists upraised, women of Iberia
towards horizons pregnant with light
on paths afire feet on the ground
face to the blue sky.
Affirming the promise of life
we defy tradition
we mould the warm clay
of a new world born of pain.
Let the past vanish into nothingness!
What do we care for yesterday!
We want to write anew the word WOMAN.
Fists upraised, women of the world
towards the horizons pregnant with light
on paths afire
onward, onward . . . toward the light.

DAME WHINA COOPER
(HOHEPINE TE WAKE)
(1895–1994)

Whina Cooper was bestowed with the name Te Whaea o Te Motu (the mother of the nation) for her work for New Zealand Māori land rights and Māori women. She was born Hohepine Te Wake in rural Hokianga to a leader of Te Rarawa iwi. As her father's favorite, she was educated at a Māori girls' boarding school where she learned to read and write English. At eighteen, she refused to enter an arranged marriage and chose instead to stay with her parents and work in the local co-operative store.

At this time, she also led a direct action against a Pakeha (white New Zealander) farmer who was draining an estuary from which Māori used to gather seafood. While a challenge to the farm's lease was dragging through the courts, Whina and her friends filled in drains as fast as the farmer dug them. The protesters were charged with trespassing, but the lease was ultimately withdrawn.

She worked for a few years as a schoolteacher and at twenty-two secretly married Richard Gilbert. They had two children and ran a farm and a store. Whina set up a post office, a doctor's clinic and, due to frustration at conventions that discouraged women from speaking on the marae (focal meeting place for the Māori community), her own community centre.

By her mid-thirties, Whina's flair and abilities in community activities made her an undisputed Māori leader of the northern Hokianga. She worked with prominent Māori politician, Sir Apirana Ngata, to promote Māori land development programmes in the Hokianga.

She created a scandal among her predominantly Catholic people when she became pregnant to a married Māori land developer, William Cooper, while her husband Richard was dying of cancer. Richard died, and William and Whina eventually had four children and later married. Whina gradually resumed a role as community leader in the late 1940s, though with less support than before.

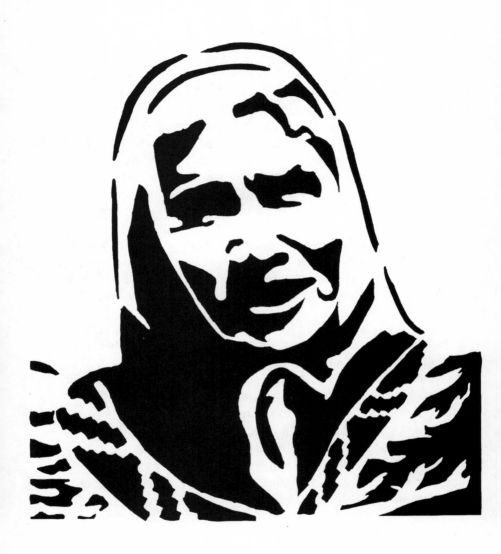

In 1949, William died, and Whina joined the Māori rural-urban migration and moved to Auckland. In the city, she became a national political figure. In September 1951, she was elected first president of the new Māori Women's Welfare League, a position she held until 1957. Largely due to Whina's efforts, the League was a great success. Whina devised programmes to improve living standards for Māori women and children, and dealt with housing, education, racial discrimination, crime, employment, and health issues.

In the 1963 elections, she stood for Northern Māori but lost; she nevertheless remained politically active in Auckland, raising funds for an urban marae and educating people about the Treaty of Waitangi, the founding document for bicultural relations in New Zealand. In the early 1970s, however, her health declined and she stated that her public life was over.

This remained true until 1975, when a coalition of Māori groups asked Whina to lead them in protest against the loss and alienation of Māori land. She accepted and proposed a march of over one thousand kilometres from one end of the North Island to the other, ending at Parliament in Wellington. Leading several thousand protestors into Parliament, eighty-year-old Whina became an icon of determination and strength.

She was made a Dame in 1981, for which she received some criticism from Māori who saw it as selling out. She replied, "They don't understand that if I accept this decoration I have more power . . . to fight for all the Māori people against the Government." She died in the Hokianga at the age of ninety-eight.

"I will die fighting for my people!"

DORIA SHAFIK
(1908–1975)

Born in Tanta, Egypt, Doria Shafik was a feminist writer and activist who played a pivotal role in the campaign for women's rights and suffrage in her homeland. A brilliant and ambitious student, she was educated in French mission schools before traveling to Paris on scholarship to study philosophy at the Sorbonne. She wrote her thesis on Egyptian women and Islam, and was awarded a doctorate in 1940. While in Paris, she married a cousin and fellow student, Nour al-Din Ragai, with whom she had two daughters.

Doria had been involved in the movement for Egyptian women's rights since her teenage years, but initially struggled to find an active role for herself on returning to Egypt. In 1945, she founded the journal *Bint al-Nil* (Daughter of the Nile) as "a vehicle for educating Egyptian and Arab women in the profound sense of that term—awakening their consciousness." Here, Doria was able to advocate in print for the causes for which she would fight throughout her career: Egyptian women's rights to vote and run for political office; the abolition of polygamy and reform of divorce law; equal pay for equal work; and an end to female illiteracy. In 1948, she founded a women's political union (later transformed into a political party, also called *Bint al-Nil*) to work actively for these objectives.

On February 19, 1951, Doria led nearly 1,500 women to storm the Egyptian parliament to demand their rights. "The freedom granted so far remained on the surface of our social structure, leaving intact the manacles which bound the hands of the Egyptian women. No one will deliver freedom to women, except woman herself." Doria was later summoned to court over the episode, but the case was never heard. In the midst of guerrilla warfare against the British, she organized armed female units to participate in the struggle but later became disillusioned by the effect of violent tactics and turned to Gandhian methods of protest.

In 1954, Doria led a group of women in a hunger strike to protest that no women had been included on the

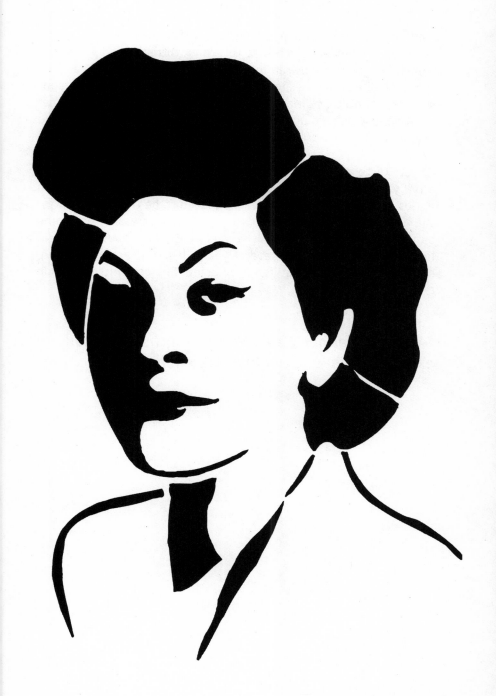

55 | DORIA SHAFIK

committee to draft Egypt's new constitution; the strike ended when promises were given that the constitution would guarantee women's rights. By now an international celebrity, Doria was able to travel extensively to promote her cause. In 1956, the new constitution granted Egyptian women the right to vote but only under conditions which did not exist for men and which Doria considered discriminatory. She announced that her struggle would continue.

In 1957, Doria embarked alone on a second hunger strike to protest the ever-increasing threat to personal liberty by Nasser's regime and to demand the withdrawal of Israeli forces from Egyptian territory. This proved to be the last straw for the authorities: Doria's publications were suppressed, her name banned from the press, and she was held under house arrest in her Cairo apartment for several years. Isolated and depressed, she spent the rest of her life in seclusion. She committed suicide on September 20, 1975.

"A nation cannot be liberated whether internally or externally while its women are enchained."

LOLITA LEBRÓN
(1919–2010)

olita Lebrón was a political dissident and longterm prisoner working for a liberated Puerto Rico. She was born in Lares, Puerto Rico, to a family of poor cigar workers. Two years before her birth, the Jones-Shafroth Act made all Puerto Ricans citizens of the United States. Spanish-speaking children were required to recite the United States' Pledge of Allegiance in class and read textbooks in English. Lolita remembers young children being forced to wet their pants if they didn't ask permission to use the bathroom in English. This, Lolita said, was a form of U.S. terrorism.

Intense battles between Puerto Rican nationalists and the colonial police were a feature of Lolita's adolescence. As she reached adulthood, a massive sterilization campaign coerced women into having "la operación," often without the knowledge that it was a permanent form of contraception: fewer women with children meant more women available to work in the factories operated by U.S. corporations in Puerto Rico.

In the 1940s, Lolita moved to New York and was confronted with signs saying "No Blacks, No Dogs, No Puerto Ricans." She worked as a seamstress during the day and went to school at night. Lolita was briefly married and had a son, whom she sent to her mother, who was already caring for Lolita's daughter in Puerto Rico.

Lolita became a follower of Dr. Pedro Albizu Campos, leader of the Puerto Rican Nationalist Party, and attended the party's meetings in New York. She corresponded with Albizu Campos while he was in prison. As a result he chose Lolita, a woman he had never met, to lead an attack on the U.S. House of Representatives on March 1, 1954, the anniversary of the Jones-Shafroth Act. Lolita was responsible for every detail. "I had all the secrets, all the plans. Me and me alone."

Never expecting to make it out alive, Lolita and her three comrades purchased one-way tickets to Washington. In the visitors' gallery above the chamber in the House of Representatives, she stood up, shouting "¡Viva Puerto Rico Libre!" (Long Live a Free

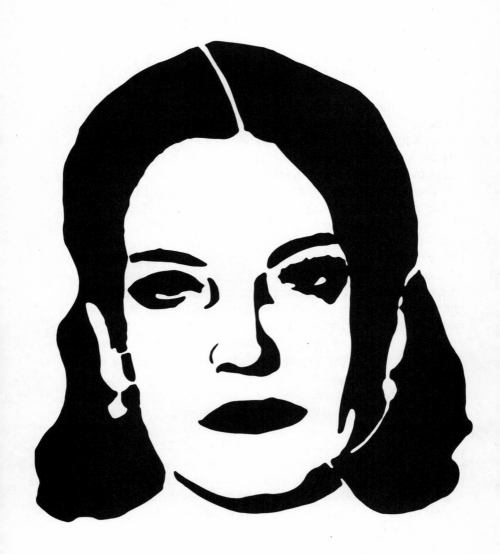

Puerto Rico!) and unfurled a Puerto Rican flag. The group then opened fire with automatic pistols, wounding five lawmakers and one representative. After her arrest, Lolita yelled "I did not come to kill anyone, I came to die for Puerto Rico." The newspapers weren't quite sure what to make of Lolita, referring to her alternately as a "terrorist leader" and a "trim divorcee."

The four comrades were charged with attempted murder and sentenced to death, later commuted to life imprisonment. Both of Lolita's children died while she was in prison. After serving twenty-five years, Lolita was pardoned by President Carter in 1979. Following her release, she appeared before cheering crowds at rallies in Chicago and New York and was welcomed as a hero in Puerto Rico by various independence groups.

In 2001, she was sentenced to sixty days in prison for trespassing in restricted areas on Vieques, a Puerto Rican island then occupied by the U.S. Navy. Such protests resulted in the U.S. Navy leaving the island in 2003. In 2005, she was one of thousands who took to the streets denouncing the FBI assassination of liberation hero Filiberto Ojeda Ríos. She advised the people to fight strategically against the imperialists who seek to silence and defeat them. On International Women's Day 2008, Lolita gave another rallying speech, telling the hundreds of women gathered, "We want everyone to know that women in Puerto Rico support, demand and are fighting for the independence of Puerto Rico."

"You must know the facts, the United States will repress anyone that tries to assert their birthright to nationhood."

HANNIE SCHAFT
(1920–1945)

Hannie Schaft was a resistance fighter who helped Dutch Jews, and carried out assassinations. She died a martyr at the hands of the Gestapo. Born Jannetje Johanna (Jo) Schaft in Haarlem, Holland, she studied law at the University of Amsterdam where she met and became friends with Jewish students.

The Germans occupied the Netherlands in May 1940 and began to persecute Dutch Jews in October. Jo started to carry out minor acts of resistance, stealing identity cards and finding safe houses for Jewish people. In 1943, German authorities demanded that all students sign a declaration of loyalty. Jo refused and, abandoning her studies, returned to Haarlem. She joined Raad van Verzet, a resistance group with ties to the Dutch Communist Party. Working under the name Hannie, she delivered ration coupons, underground pamphlets, secret information, and weapons.

But Hannie felt she could be doing more. She began working with Truus and Freddie Oversteegen, two teenage sisters. The three women became legends among resistance fighters as they committed assassinations and sabotage, activities usually carried out by men. The successful trio was soon on the Gestapo's most wanted list. Hannie was known to the Gestapo as the "girl with red hair." She went into hiding, dyeing her hair black and wearing a pair of glasses. Truss would often dress as a boy and they would carry out actions posing as a couple. Sometimes they carried out assassinations while on a bicycle, Hannie sitting on the back and doing the shooting.

In June 1944, Hannie and Jan Bonekamp, a fellow resistance fighter and her close friend, went to kill notorious police chief, W. Ragut. Jan was shot and captured by the Germans. It is believed the Germans tricked him into revealing Hannie's identity before he died. She was greatly affected by Jan's death, writing to a friend, "I'm not as tough as I thought I would be: the acquaintance with death fell hard on me." Hannie's parents were arrested and held at a concentration camp in Vught for nine months in an effort to make her turn herself in. But Hannie always held firm to

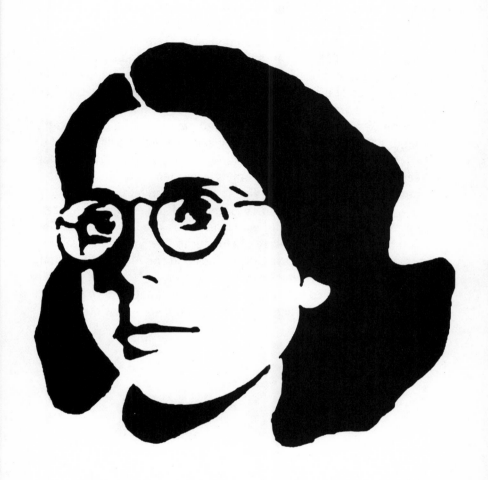

her integrity. She once refused a mission that involved kidnapping the children of a Reich's commander, asserting, "We are no Hitlerites, Resistance fighters do not murder children."

Hannie was stopped at a German checkpoint in March 1945. Soldiers searched her and found copies of an illegal newspaper and a pistol. After hours of interrogation, she was recognized as the wanted "girl with red hair." She was tortured for days, but would only admit to one assassination, that of Ko Langendijk, a hairdresser who betrayed people to the Germans for money. On April 17, 1945, three weeks before the liberation of the Netherlands, Hannie was taken to dunes near Overveen to be executed. After the first shot only grazed her, Hannie shouted, "I shoot better than you!" She died in a hail of bullets.

After the war, the remains of 422 resistance fighters were recovered from the dunes. Hannie was the only woman. She was reburied in the Cemetery of Honour in Overveen in November 1945 and received the Resistance Cross and the Medal of Freedom posthumously. Every year, on the last Sunday in November, people gather in Haarlem to commemorate Hannie Schaft and to show an ongoing resistance to racism, fascism, and discrimination.

HAYDÉE SANTAMARÍA CUADRADO
(1922–1980)

Haydée Santamaría Cuadrado was a Cuban revolutionary and advocate of politically dissident artists. She was born on a sugar plantation in central Cuba, one of five children born to small-time landowners of Spanish descent. In the early 1950s, Haydée moved to Havana with her younger brother Abel and both siblings became involved with the growing movement against the corruption of the Batista dictatorship. By the end of the revolution, the whole Santamaría family was involved in direct action.

On July 26, 1953, Haydée was one of two women who participated in the assault, headed by Fidel Castro, on the Moncada garrison. One hundred and twenty rebels attempted to take Moncada with the objective of securing the weapons kept there. The attack resulted in the deaths of two-thirds of the insurgents, some in the fighting and some (including Haydée's brother Abel and lover Boris) during the capture and torture by the Batista regime. Haydée was imprisoned and tortured. The guards brought her the bleeding eye of her brother and threatened to tear out his other eye, but she replied "If you tore out an eye and he did not speak, neither will I."

She was eventually released, and smuggled out of prison page-by-page Fidel Castro's famous defense, *History Will Absolve Me.*

Haydée later joined Castro and Che Guevara's guerilla fighters in the Sierra Maestra mountains and fought during the war in the "Marianas," a women's battalion of the rebel army. She also travelled to the United States to raise funds and purchase equipment, spending the war as a gunrunner, tactician, international fundraiser, coordinator of the urban underground, and guerrilla combatant.

Following the victory of the revolution on New Year's Day 1959, Haydée founded a cultural institution called la Casa de las Américas. As its director for twenty years, Haydée provided intellectual and physical refuge for artists and writers in exile from Latin American dictatorships.

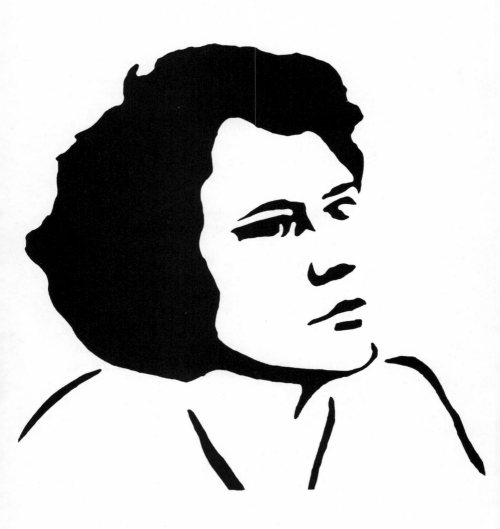

Haydée's communist philosophy embraced internationalism and was always opposed to "sovietization" or imposing rigid Stalinist bureaucracy and dogmatic thought on Cuba. She had no time for dogmatism or for so-called socialist realism.

La Casa de las Américas published numerous books by Latin American dissidents which were too controversial to be published at home. Casa also brought some of the world's most celebrated dancers, musicians, painters, and theater groups to the island as part of the revolutionary imperative to rectify decades of cultural elitism and to bring art to the Cuban people. Casa houses one of Latin America's most extensive art collections and libraries.

During the 1960s, Haydée and her fellow revolutionary Armando Hart Davalos had a son and a daughter, whom they named Abel and Celia.

Haydée had a near-fatal car accident in 1980 that left her in constant pain. She committed suicide several months later.

"There is a moment when all things can be beautiful, heroic. That moment when life defies death and defeat, because one holds on to it, because it's so important not to lose it. At such a moment, one risks everything to preserve what really counts. Life and death can be beautiful and noble, when you fight for your life, but also when you give it up without compromise. All I have wanted to show our young Cubans is that life is more beautiful when you live that way. It is the only way to live."

ONDINA PETEANI
(1925–2003)

Ondina Peteani was a member of the Italian antifascist resistance during World War II and a postwar political activist. She was born in Trieste, Italy. Raised under Fascism, she was first drawn into antifascist activism in 1942 as a worker at the shipyard in Molfalcone. As most of her antifascist comrades were communists, she was also drawn into communism. With partisans of the Slovenian Liberation Front already operating in the region, the activists were moved to form Garibaldi Unit, Italy's first partisan group, in early 1943. Using the code-name "Natalia," Ondina worked for the Garibaldi as a courier, bringing food and news to the partisans. She was arrested on July 2, 1943, and imprisoned in Trieste until the aftermath of the Italian armistice with the Allies on September 8.

During the subsequently invasion of Italy by its former ally Germany, Ondina rejoined the partisans. Women played an important part in the Italian resistance to Nazi Germany and to the Italian Social Republic, the revived Fascist state in Northern Italy, both as couriers and as combatants, often paying with their lives. Ondina was twice arrested and twice managed to escape before she was captured on February 11, 1944, and imprisoned once again in Trieste. At the end of March, she was deported to Auschwitz and later transferred to Ravensbrück. She was assigned to be a laborer in a factory in Berlin, where she managed to sabotage production by slowing the work process. In April 1945, she was to be marched back to Ravensbrück, but managed to escape and returned to Italy via Eastern Europe in July 1945. She was still only twenty years old.

Ondina suffered the physical and psychological effects of her wartime experiences for the rest of her life. Of her ordeal, she said: "I do not know what a dream is. From 1944 I very well know what a nightmare is." But this did not prevent her from living a rich and committed life as a midwife, militant in the Italian Communist Party, and trade-unionist. Her past left her passionately committed to the cause of antiracism and she was an active

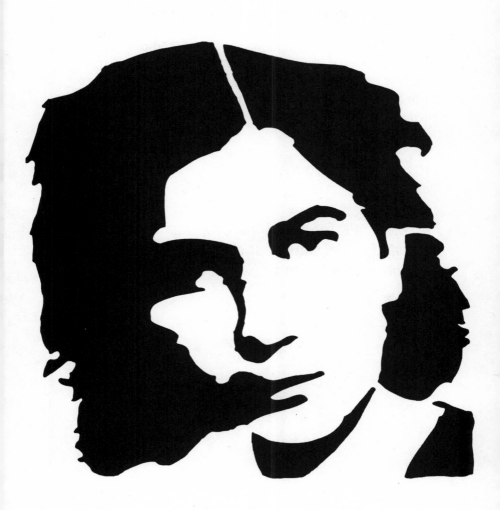

member of the Associazione Nazionale Partigiani d'Italia for former resistance fighters. She was also known for her organization of cultural activities, such as summer camps for left-wing youth and the circle around the communist publishers Editori Riuniti, which she ran with her partner Gianluigi Brusadin.

Suffering from emphysema, Ondina was confined to her apartment starting in 1991. She died twelve years later, aged seventy-seven.

"It is beautiful to live free."

"Against all forms of racism, against discrimination and racial abuse: social, cultural and religious. Stubbornly; Now and Always: Resistance!"

ANI PACHEN
(1933–2002)

Ani Pachen was a Buddhist nun, Tibetan freedom fighter, and political prisoner. She was born Pachen Dolma in Gonjo, Kham, Eastern Tibet, the only child of a chieftain of the Lemdha people. From a young age she was more interested in a spiritual life than the political one into which she was born. Aged seventeen, she overheard plans of her arranged marriage to the son of another chieftain and fled to a monastery that took three weeks to reach while riding horseback.

She became a Buddhist nun and lived in the monastery for the next eight years until her father's death in 1958. During the Chinese invasion of Tibet, Ani Pachen chose to go against her nonviolent Buddhist teachings and lead her people in armed resistance. Her father had taught her how to ride and shoot when she was a girl, and she proved an effective guerilla leader, earning the name Ani Pachen, Nun of Great Courage. Her six hundred horseback fighters held back the Chinese army for several months but were eventually overcome. She was captured in late 1959.

For the next twenty-one years, Ani Pachen suffered inhumane conditions as a political prisoner, and was tortured for adhering to her faith and for her refusal to denounce the Dalai Lama. She was routinely beaten and hung by her wrists for a week at a time, spent a year in leg irons and was held for nine months in solitary confinement in an unlit cell. In 1970, she was transferred to Drapchi prison in the Tibetan capital, Lhasa, where many of her friends and compatriots were also held. Conditions were appalling and many of the prisoners who weren't executed died of starvation. From prison, Ani Pachen saw the smoke rise from the Three Great Monasteries of Lhasa (Drepung, Sera, and Ganden) as they were burned and ransacked.

Ani Pachen was finally released in January 1981 and continued resisting the Chinese invasion. She remained in Lhasa and took part in three major demonstrations led by the displaced monks of Drepung, Sera, and Ganden Monasteries in

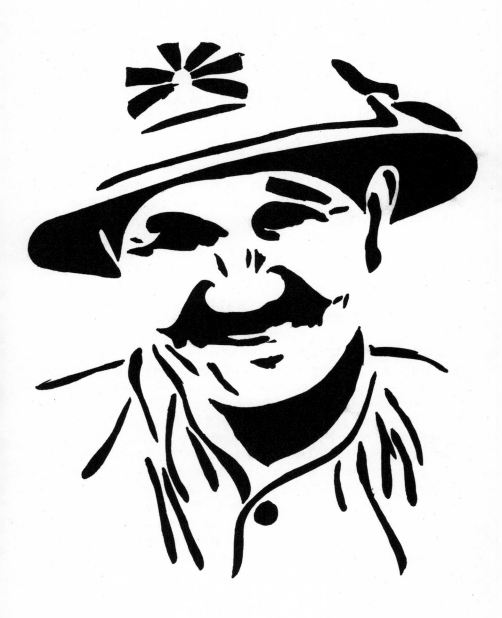

1987 and 1988 to demand human rights for Tibetans and for the Chinese to leave Tibet.

Upon learning that she was going to be arrested, Ani Pachen fled for the Nepalese border and got lost in the snow for fours days before finding a friendly villager who took her in. After finding a guide, she walked for twenty-five days to reach Nepal. Finally arriving in Dharamsala, India, where the Dalai Lama lives in exile, she was honoured by a personal audience with him—the hope of which had kept her determination strong throughout her ordeals.

With the help of an American writer, Ani Pachen wrote an autobiography that was published in 2000 and reached a large western audience. Over the next two years, she toured the United States and Europe as a speaker to help garner support for the plight of Tibet. She died in 2002 of heart problems that stemmed from her treatment in prison.

"Here many people are concerned about the endangerment of animals. This is good. But I am talking about an entire culture. Tibetan culture is on the verge of extinction."

DJAMILA BOUHIRED
(B. 1935)

Djamila Bouhired is an Algerian Nationalist, an Arab Muslim, and a feminist. She fought colonial rule and was captured, tortured, sentenced to death and went free. She was born in the Casbah, in Algeria's capital, Algiers, to a middle-class family, and was educated at a French school. While a student activist, Djamila joined the Algerian National Liberation Front (FLN) and became the liaison officer and personal assistant to FLN commander, Yacef Saadi.

In 1957, during the long and bloody war of Algerian independence, Algiers was placed under French military control as a response to a series of armed attacks by urban guerrillas and the FLN's call for a general strike. Women wearing the veil could more easily carry out resistance work than men, and Djamila and other women held meetings in the Casbah, urging people to continue with the seven-day strike. She was a fiery speaker and had the advantage of speaking the local Casbah dialect.

In April 1957, during a confrontation between resistance fighters and French troops, Djamila was shot in the shoulder. She was subsequently captured and accused of planting bombs, namely the "Milk Bar" bomb of September 30, 1956 that killed eleven people and wounded five. Following her arrest, Djamila was tortured for seventeen days. She admitted being a rebel courier, denied she had any part in the bombings, and refused to disclose the hiding place of Yacef Saadi.

In court, she was defended by French lawyer Jacques Verges. Rather than protest her innocence, her defence challenged the court's right to judge her. "The truth is that I love my country; I want to see it free. And it is for this and this alone, that you have tortured me and are going to condemn me to death. But when you kill us do not forget that you are killing your own country's tradition of liberty." She was convicted of terrorism and sentenced to death, but a media campaign instigated by Verges resulted in overwhelming world condemnation of the decision. Her execution was blocked: Djamila had become an international symbol of anticolonialist resistance.

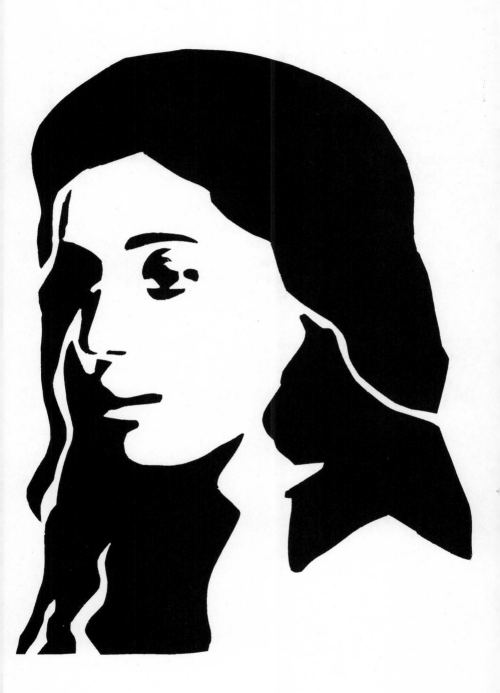

She was released from prison in 1962 when Algeria won independence. She toured Arab countries as a folk heroine in the following year, married Jacques Verges, and had two children.

Unfortunately, the participation of women in the war did not lead to gains for women in independent Algeria. Speaking in 1971, Djamila said: "We are still in a struggle to make our new country work, to rebuild the destroyed family, to preserve our identity as a nation. In the future, perhaps we will arrive at a kind of life where men and women relate on a more friendly basis. I hope so."

In 1981, she and other women took to the streets to protest a conservative family code proposed by the government. The proposed bill was withdrawn, but the government passed a similar family code three years later. In 1992, Djamila led demonstrations against the Family Code, which puts women under the control of their fathers or husbands.

"The day I was sentenced to death was the most beautiful day of my life. Because I was about to die for the most beautiful cause on earth."

ANGELA DAVIS
(B. 1944)

Angela Davis is an African-American activist and intellectual whose time in prison led her to campaign against the prison-industrial complex. She was born into institutionally segregated Birmingham, Alabama, in the United States. An avid reader since childhood, she went to high school in New York City where she was exposed to socialism and became an activist. She got a scholarship to Brandeis University in Waltham, Massachusetts, where she was one of three Black students. She later studied philosophy in Europe and in America under Marxist Herbert Marcuse. She has a PhD from Humboldt University of Berlin.

In the 1960s, Angela was active with the SNCC (Student Nonviolent Coordinating Committee) and the Black Panthers. "My sisters," she said, "if we cannot agree on the simple fact that the white man is dragging us by our heels to the deep dark pits of hell, what can we agree on? We must unite against the great white demon. Together we may overpower white America and bring rise to Black Power!"

The militancy and passion of Black Power politics appealed to her, although she was also involved with communism, which Stokely Carmichael's crew rejected as a "white man's thing." In 1969, she got fired from her position as lecturer at the University of California for her activism and for belonging to the communist party. A public outcry followed, forcing the university to re-employ her.

Angela was active in the campaign to free George Jackson and other African-American political prisoners held in California. On August 7, 1970, Superior Court Judge Harold Haley was abducted from his courtroom in Marin County, California, along with other hostages and killed during an effort to free convicts. Three others were also killed, including George's brother Jonathan. Angela was implicated as the guns used had been registered in her name. She evaded the police for two months and was placed on the FBI's Ten Most Wanted List.

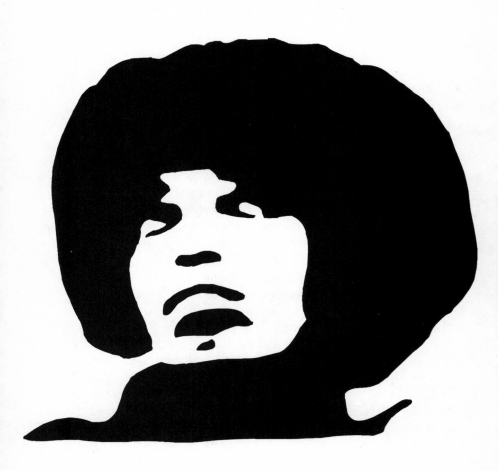

After a high-profile trial and a huge international "Free Angela Davis" campaign, she was acquitted by an all-white jury after spending eighteen months in jail. Her time inside fueled her later activism for abolishing the highly privatised and steadily growing U.S. prison system, which she calls the "Punishment Industry." She also cofounded the National Alliance Against Racism and Political Repression and in 1980 and 1984 ran for Vice President of the United States on the Communist ticket along with the party leader Gus Hall as a lead candidate.

In 1998 she helped found Critical Resistance, an international movement that seeks to end the prison industrial complex by challenging the belief that caging and controlling people makes the population safe. The movement states that basic necessities such as food, shelter, and freedom rather than incarceration stabilise communities. "Jails and prisons are designed to break human beings, to convert the population into specimens in a zoo—obedient to our keepers, but dangerous to each other."

She has published several books on racial politics, institutionalised racism and feminism as well as an autobiography. She is currently a professor at the University of California and continues to lecture internationally.

"You can't ask a mother to moderately snatch her baby out of a burning house."

"Radical simply means 'grasping things at the root.'"

"Revolution is a serious thing, the most serious thing about a revolutionary's life. When one commits oneself to the struggle, it must be for a lifetime."

LEILA KHALED
(B. 1944)

Leila Khaled is a Palestinian freedom fighter, a hijacker turned politician. She was born in coastal Haifa, annexed by the United Nations for Israel after World War II. In the ensuing fighting, Leila's family was forced to flee to a refugee camp in Lebanon, leaving behind her politically active father. Leila committed herself to armed struggle at the age of fifteen, joining the movement that later became the Popular Front for the Liberation of Palestine (PFLP).

Leila hijacked her first passenger plane, en route from Rome to Athens, in 1969 when the PFLP mistakenly thought the Israeli ambassador to the United States would be on board. Leila ordered the pilot to fly over Haifa, which she was not allowed to visit, then landed it in Damascus. No one was hurt, although hostages were taken and the aircraft was later blown up.

After the hijacking, Leila's image was printed internationally and she unintentionally became the poster girl of armed struggle. To conceal her identity, she had six plastic surgeries to modify her chin and nose, all without general anaesthetic. "I have a cause higher and nobler than my own, a cause to which all private interests and concerns must be subordinated."

In 1970, with her new face, she undertook a second hijack as she and a comrade attempted to storm the cockpit of an El Al jet from Amsterdam. Removing the pins from her grenades with her teeth, Leila ordered the captain to let them in. But Israeli sky-marshals shot her comrade and eventually managed to hit Leila over the head so she lost consciousness.

"When I woke up I was tied up and being kicked. Passengers were shouting; I heard a woman scream, 'Stop the bloodshed.' But we had very strict instructions: don't hurt the passengers. Only defend yourselves. I did not want to blow up the plane. It [the grenade] was only to threaten."

The plane landed in London and Leila was held in custody for twenty-eight days until the Prime Minister released her in exchange for western hostages held by the PFLP.

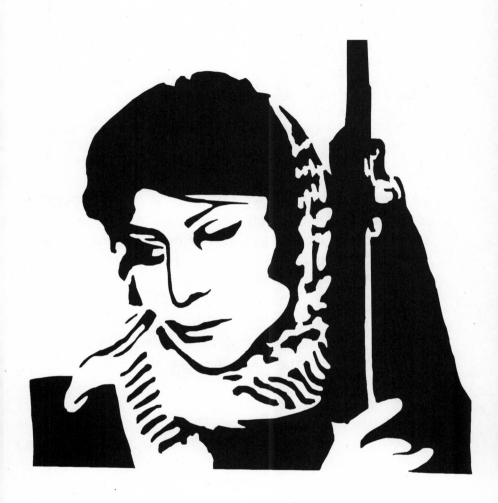

Leila continued to fight for freedom upon her return to Palestine as an activist and later as a politician for the PFLP on the Palestinian National Council. Her politics are still radical, and she calls for the withdrawal of Israel from all the land it has occupied since 1967. "It's not a peace process. It's a political process where the balance of forces is for the Israelis and not for us. They have all the cards to play with and the Palestinians have nothing to depend on . . ."

She speaks regularly at international forums. She lives in Jordan with her family.

"In the beginning, all women had to prove that we could be equal to men in armed struggle. So we wanted to be like men—even in our appearance . . . I no longer think it's necessary to prove ourselves as women by imitating men. I have learned that a woman can be a fighter, a freedom fighter, a political activist, and that she can fall in love, and be loved, she can be married, have children, be a mother . . . Revolution must mean life also; every aspect of life."

ANNA MAE AQUASH
(1945–1975)

An educator and protestor, Anna Mae Aquash was one of the most active and prominent female members of the American Indian Movement. She grew up on a Mi'kmaq reserve in Nova Scotia, Canada. At the age of eleven, she started attending an off-reserve school and would later claim that her school years were ruined by unrelenting racial slurs and lewd comments. When she was in ninth grade, Anna Mae's mother abandoned her and her siblings. Anna Mae then left school and joined the annual migration from the reserve to work the berry and potato harvests in Maine.

Soon, she became a factory worker in Boston, had two daughters with Jake Maloney, another Mi'kmaq, and married him in 1965, though the marriage didn't last. In 1969, she helped found the Boston Indian Council. She participated in the American Indian Movement (AIM) convergence on the Mayflower II on Thanksgiving Day, 1970, and this protest strengthened her commitment to work for native rights.

She became involved in bicultural education projects. In 1972 she travelled to Washington, D.C., with her partner, Nogeeshik Aquash, for the Trail of Broken Treaties march and took part in the occupation of the Bureau of Indian Affairs building.

The following year, Anna Mae joined AIM's seventy-one-day armed occupation of Wounded Knee. She and Nogeeshik were married in a traditional Lakota ceremony during the occupation. They separated in 1974 and Anna Mae started working at AIM's national office in Minnesota. She became a respected organizer, travelling across the United States, joining protests, fundraising and helping establish education programs. She rose through the ranks of AIM, becoming close to leaders Leonard Peltier and Dennis Banks.

Anna Mae returned to the Pine Ridge Reservation, site of the Wounded Knee occupation, in 1975. On June 26, a shootout broke out on the reservation, killing two FBI agents and one AIM supporter. The FBI believed Anna Mae had information on

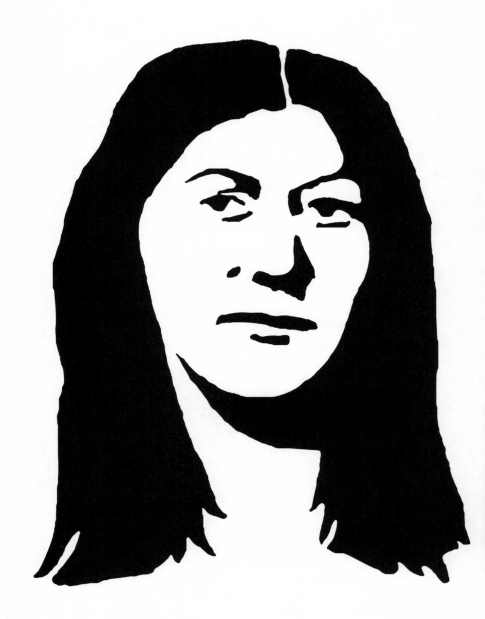

the killings and arrested her twice in the fall of 1975. Anna Mae claimed an FBI agent told her she'd be "dead within a year" if she didn't cooperate. Fearing the worst, she went underground.

On February 24, 1976 Anna Mae's body was discovered on the outskirts of the Pine Ridge Reservation. An autopsy at which the FBI were present, found that "she had died of exposure." Her hands were cut off and sent to the FBI for finger printing, and she was hastily buried in a pauper's grave, unidentified and without a burial permit.

When the FBI announced that the body was Anna Mae's, her family demanded another autopsy. This second independent autopsy revealed that she had been shot by a .32 caliber bullet in the back of the head. Accused of a cover-up, the FBI denied any involvement in her murder and speculated that she had been killed by AIM as a suspected informant.

Only thirty years old when she died, Anna Mae lives on as a symbol of indigenous resistance.

"These white people think this country belongs to them—they don't realize that they are only in charge right now because there's more of them than there are of us. The whole country changed with a handful of raggedy-ass pilgrims that came over here in the 1500s. And it can take a handful of raggedy-ass Indians to do the same, and I intend to be one of those raggedy-ass Indians."

ASSATA SHAKUR
(B. 1947)

Assata Shakur is a Black activist, FBI target and political fugitive. She was born JoAnne Byron in Queens, New York City. Her parents divorced when she was three and she was raised at various times by strangers; her grandparents in North Carolina; and her aunt, who helped her get a high school equivalency diploma.

She went to college and was arrested for the first time in 1967 for trespassing while protesting a deficient Black curriculum. She married fellow student-activist Louis Chesimard, but they divorced in 1970 over disagreements about gender roles. She changed her name to Assata Shakur and became involved in the Black Panther Party, the Black Liberation Army, and the Republic of New Afrika. She was involved in the free breakfast program for poor kids and focused on teaching Black history to Black people who had been brought up with the white version as the objective truth.

After allegedly being involved in a series of Black Panther bank robberies, Assata became the subject of a nationwide manhunt in 1971. When she was finally captured in 1972, however, she was not charged with a crime.

In May 1973 a trooper on the New Jersey Turnpike stopped Assata, along with Zayd Shakur and Sundiata Acoli, for driving with a broken taillight. Zayd was asked to get out of the car, and a shootout ensued, leaving Zayd and the trooper both dead and Assata wounded—she had been shot in the chest although she had her hands above her head. She spent the next four years in custody and on trial for charges relating to several incidents in which she had allegedly been involved between 1971 and 1973, including bank robberies, kidnapping, attempted murder, and eight other felonies relating to the turnpike shootout.

The final trial in 1977 resulted in Assata being convicted of murder and assault and sentenced to life in prison. When the verdict was announced, she said that she was "ashamed that I have even taken part in this trial" and that the jury was "racist" and had "convicted a woman with her hands up."

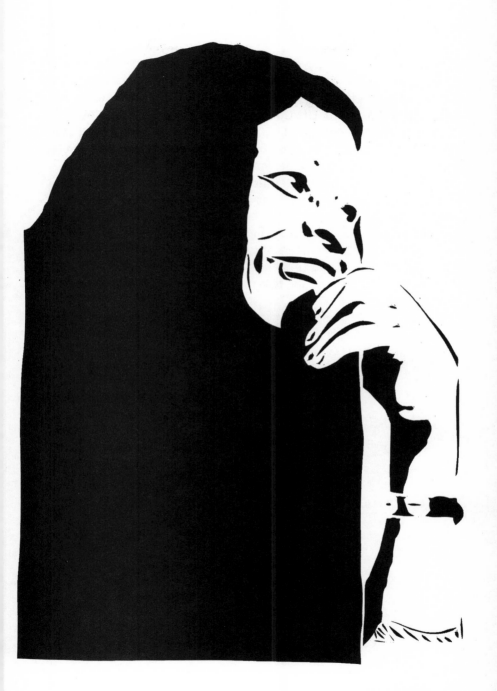

Assata was transferred through several different prisons and gave birth to her daughter (conceived during her trial) in the fortified psychiatric ward at Elmhurst General Hospital in Queens. Her newborn baby was immediately taken away from her. Assata conditions of incarceration during the next six years were abysmal. The UN Commission of Human Rights stated that her treatment was "totally unbefitting any prisoner" and that she had been targeted as a political activist by the FBI's COINTELPRO counterinsurgency campaign.

In 1979, four members of the Black Liberation Army entered the prison that held Assata, drew concealed weapons, took prison guards hostage, and escaped with Assata in a prison van. She lived as a fugitive for several years. The FBI circulated "wanted" posters throughout the New York–New Jersey area, and her supporters hung "Assata Shakur is Welcome Here" posters in response. She fled to Cuba in 1984 to live under political asylum.

In 2005, the FBI upped the ante by reclassifying her as a "domestic terrorist" with the reward for assistance in her capture set at $1 million. This has once again forced her underground after living relatively openly for twenty years.

"The only way to live on this planet with any human dignity at the moment is to struggle."

"Only the strong go crazy. The weak just go along."

BRIGITTE MOHNHAUPT
(B. 1949)

Brigitte Mohnhaupt is an anti-imperialist, anticapitalist urban guerrilla. She was a leader in the Red Army Faction whose actions shook West Germany to its core. She was born in Rheinberg, West Germany. In 1967, while studying philosophy in Munich, she became involved in the local commune scene and met influential figures of the 1960s student movement. She protested against the Vietnam War at the USA Cultural Centre and was part of the Socialist Patients Collective (SPK), a revolutionary patients' group that believed capitalism was the reason for illness. "The system has made us sick. Let us strike a death blow to the sick system."

Following the decline of the SPK around 1971, Brigitte joined the Red Army Faction (RAF), a militant urban guerilla group. Angered by the Vietnam War, West German capitalism and the fascist leanings of the country's elite, the RAF carried out bombings, robberies, and murders. They hoped the state's repressive response to their actions would bring about a revolution. Brigitte helped with organization, logistics, and weapon procurement.

In June 1972, she was arrested in Berlin and sentenced to prison for involvement with a criminal organization, identity document forgery, and possession of illegal weapons. Soon after the death in prison of one of the RAF's founding members, Ulrike Meinhof, Brigitte requested and was granted a transfer to Stanheim Prison. Most RAF prisoners were already in Stanheim, including leaders Gudrun Ensslin and Andreas Baader. It is believed that they trained Brigitte to become a leader of the RAF while she was in prison.

Released in February 1977, Brigitte immediately went underground and became a leader of the RAF's second generation. She was involved in the assassinations of chief federal prosecutor Siegfried Buback and banker Jürgen Ponto. On September 5, 1977, the RAF kidnapped former SS officer Hanns-Martin Schleyer, then president of the German Employers' Association. The events that followed led to a national crisis known as "German Autumn."

In exchange for Schleyer, the RAF demanded the release of RAF prisoners. But on October 18, 1977, Ensslin, Baader, and another RAF prisoner, Jan-Carl Raspe, were found dead in their cells. Schleyer was killed in response.

In 1978, Brigitte was arrested in Croatia but went free after West Germany refused to release Croatian political fugitives in return for her extradition. In 1981, she took part in the attempted murder of General Frederick Kroesen, commander of American forces in Europe, using an antitank grenade.

In 1982, Brigitte was caught by West German authorities when entering one of the RAF's arms caches in forest near Frankfurt. Police had been surveilling the area for two weeks, following a tipoff from locals who had stumbled upon the cache. In 1985, Brigitte, who had been called "the most evil and dangerous woman in Germany," was sentenced to five terms of life imprisonment. Following her conviction, she declared that the RAF would continue to fight. Seven years later, the RAF abandoned violent tactics and the group disbanded in 1998 in a decision that Brigitte supported.

While in prison, Brigitte never gave an interview and never asked for a pardon. After serving twenty-four years, she became eligible for parole. The prospect of her release sparked fierce debate within Germany. Some advocated that she had spent more time in prison than Nazi war criminals, while others objected that she had never expressed any remorse for her actions. A Stuttgart court approved her parole and she was freed in March 2007.

"The revolution says: I was, I am, I will be again."
—Red Army Faction's final communiqué

SYLVIA RIVERA
(1951–2002)

Sylvia Rivera was an American transgender activist of Puerto Rican, Venezuelan, and Mexican descent. Born Ray Rivera Mendoza, he left home at the age of ten, and lived and worked on the streets of New York City, dressing in drag. Sylvia and other young hustlers and drag queens were subjected to violence and police brutality, often arrested and beaten and raped within the cells. This situation came to a head during the Stonewall Riots, a catalyst for the modern-day gay rights movement.

The Stonewall Inn was a popular gay bar in Greenwich Village with a diverse racial mix. The bar was regularly raided by the police, and female patrons would be arrested for not wearing at least three items of "feminine clothing" and males for dressing in drag. In June 1969, police raided the Inn, but this time patrons fought back. Sylvia Rivera is said to have thrown the first bottle at the police, and soon Molotov cocktails were thrown and a parking meter was used as a battering ram. The crowd had the police trapped inside for at least forty-five minutes, as the patrons fought for the right to be themselves without harassment. Sylvia has been quoted as saying that she felt that the revolution had finally arrived.

In 1970, Sylvia was a founding member of the Gay Liberation Front, and the Gay Activist Alliance (GAA), and was involved in the campaign to pass the New York City gay rights bill. Never attempting to fit in to the mainstream, Sylvia wore a dress and high heels when she tried to force her way into a closed door session concerning the bill. The GAA soon dropped transvestite and drag issues from their campaign in order to appear more conventional and "normal." Disillusioned and disappointed, Sylvia backed away from the GAA.

During that same year, Sylvia formed a group called STAR (Street Transvestite Action Revolutionaries) with African-American transgender activist Marsha P. Johnson. STAR fought for transgender rights and also provided practical help, opening

STAR House to provide shelter for homeless transgendered youth. STAR lasted for two years, and was the first of its kind in NYC. Significantly, STAR formed alliances with other youth groups of color, such as the Black Panthers.

By the late 1970s, Sylvia was homeless and broke due to substance-abuse issues. By 1997, she was living at the Transy House Collective, which was inspired by and based on STAR, and was also run by transgendered people. Here, she provided support for transgendered youth, restarted her activism, and reformed STAR in 2000. She worked towards goals such as the Human Rights Commission being more inclusive of trans issues.

Sylvia Rivera died of liver cancer, but conducted meetings with other activists from her hospital bed even a few hours before her death. She was a courageous lifelong activist, fighting for the rights of those excluded not just from mainstream heteronormative society, but also from the mainstream gay rights movement—people of color, low income queers, trans people, and homeless youth. In her honor, the Sylvia Rivera Law Project has been established to: "guarantee that all people are free to self-determine their gender identity and expression, regardless of income or race, and without facing harassment, discrimination or violence."

OLIVE MORRIS
(1952–1979)

Black women's movement activist, civil rights activist, and spokesperson for the community, Olive Morris was an inspirational driving force behind antiracist activism and squatting culture in South London throughout her short life.

She moved to the UK from the West Indies to join her parents when she was about eight years old. At seventeen, Olive witnessed a Black man being harassed by the police in Brixton, and along with a group of other young friends, stepped in to help him. This led to her arrest and a subsequent beating from the police. Although this was probably not the first time Olive was involved in fighting oppression, this incident is often referred to as the moment she became publicly known for her activism.

Olive became a member of the Brixton Black Panther Movement and was a founding member of the Organisation of Women of Asian and African Descent and the Brixton Black Women's Group. She also worked with others to set up Sarbarr, a Black community bookstore.

Olive became a symbol of the squatting movement in Brixton, particularly after an iconic photograph of her was used on the cover of the 1979 edition of the Squatters Handbook. In 1972, she and her friend Liz Obi were homeless and had little money, like many Black young people in Lambeth at the time. They moved into 121 Railton Road, a privately owned building above a laundrette. This was the first time a privately owned building was successfully squatted in Lambeth. Over the years, the women resisted eviction attempts and were arrested many times. Though Olive and Liz eventually moved, 121 continued to be squatted until 1999, making it one of the longest squats in Brixton.

In 1975, Olive moved to Manchester to go to University. There, she cofounded the Manchester Black Women's Co-operative, later reformed as the Abasindi Co-operative. The aim of the group was originally to form a self-help, educational program for young mothers. Olive also involved herself in the campaign

with Black mothers to demand better education for their children, and helped set up a supplementary school and a Black bookshop. In 1979, at the age of twenty-seven, Olive died of cancer.

Olive Morris remains a local hero in Lambeth, a symbol of determination and fighting spirit—her life was dedicated to fighting injustice, and promoting education and self-reliance in her community. She made a big impact, and many people are currently working to keep her legacy alive through projects such as Remembering Olive Collective, a women's group researching information and creating public memories about Olive's life and achievements, and the social climate in which they occurred. Much of the information here has been drawn from their site: http://www.rememberolivemorris.wordpress.com.

VANDANA SHIVA
(B. 1952)

Vandana Shiva is an eco-feminist and environmental activist who uses her knowledge and reputation as an authority on environmental impact to assist movements all over the world. She was born in Dehradun, India, in the Himalayas. She completed a B.S. in Physics, then an M.A. in the Philosophy of Science.

While working on her PhD (which she finished in 1979) she got involved with the Chipko movement, a group of primarily women activists who literally hugged trees to prevent felling in protest of the commercial logging industry which was destroying their ecosystems and livelihoods. "I have often called Chipko my University of Ecology and the women of Chipko my Professors, even though they had never been to school . . . literacy is not a prerequisite for knowledge, and ordinary tribals, peasants, women have tremendous ecological experience. They are biodiversity experts, seed experts, soil experts, water experts. The blindness of dominant systems to their knowledge and expertise is not proof of the ignorance of the poor and powerless. It is in fact proof of the ignorance of the rich and powerful."

In 1982, Vandana left her academic career to found the Research Foundation for Science, Technology and Ecology in her mother's cowshed. The Foundation's focus was biodiversity conservation and its ethos was that participatory research by people working in the field is more authentic and useful than that carried out in the "ivory tower of privileged academic institutions." It became a people's movement whose impact went global, changing paradigms in agriculture and land use from monoculture to diversity, exploitation to sustainability, and challenging biopiracy patents, and winning in the cases of neem and basmati. The Foundation's work has been fundamental in helping build the global resistance to genetically engineered crops.

Vandana has worked as an ecology advisor for governmental and nongovernmental organizations. She is one of the leaders of the International Forum on Globalization and a figure of the global solidarity movement known as the alter-globalization

movement, one of many "new global movements connected through our common concerns and common humanity . . . based on our care for the earth and the compassion for each other." She has argued for the wisdom of many traditional practices, such as India's Vedic heritage.

In 1991, Vandana founded Navdanya, which literally means "nine seeds," to protect the diversity of native seeds in India by helping local farmers reject political and economic pressures to sell out. The core of this movement is based on Gandhian principles of self-reliance, nonviolence and noncooperation: "Any law that tries to say that (our freedom) is illegal . . . we will have to not cooperate with it. We will defend our freedoms to have access to water, access to seed, access to food, access to medicine."

In 1993, she was the recipient of the Right Livelihood Award, considered the "Alternative Nobel Prize." Vandana is the author of more than fifteen books and over three hundred scientific papers.

"I don't want to live in a world where five giant companies control our health and our food."

"It is time to learn from the mistakes of monocultures of the mind and the essentialising violence of reductionist thought. It is time to turn to diversity for healing."

"Greed creates scarcity, and we're living in periods of scarcity. We need to have abundant thinking. We need to think generously to be able to generate generously."

COMANDANTE RAMONA
(1959–2006)

Comandante Ramona was an indigenous street seller turned revolutionary leader, whose story has given hope and inspiration to thousands of marginalized people all over Mexico. Born in a Tzotzil (Mayan Indian) community in the highlands of Chiapas, southern Mexico, Ramona made a meagre living selling her embroidery to tourists in San Cristóbal de las Casas. She gradually became politicized as she realised that the abject poverty in which her people live (over 60 percent suffer from malnutrition while forced to grow export cash crops on their fertile land) was not going to improve without a fight. "I believe that it is better to die fighting than to die of hunger."

Ramona joined the EZLN (Zapatista Army for National Liberation), learned to speak Spanish, and began work politically awakening the women in Chiapas. On January 1, 1994, the Zapatistas emerged from their headquarters in the Lacandona jungle to take over all the major towns in Chiapas. Ramona was one of the leaders in these actions. The authorities fought back hard and dirty, but despite setbacks the Zapatistas continue to this day with their struggle for autonomous indigenous governing of their state-confiscated lands.

Ramona was one of seven female comandantes on the Clandestine Revolutionary Indigenous Committee that directs the EZLN. Women make up about a third of the Zapatista army and supply the majority of the support work such as cooking, security, sewing, weaponry-making, organizing, and mobilising the people.

Ramona helped create the Women's Revolutionary Law, which is part of the EZLN's revolutionary law. The main articles include women's rights to decide on their number of children; work for a fair wage; participate in revolutionary struggle and community affairs; hold political office and military ranks; have access to health care, nutrition and education; choose partners and not be forced into marriage; and not tolerate physical abuse or rape.

Ramona worked with the women in indigenous communities to affect change and get together lists of demands.

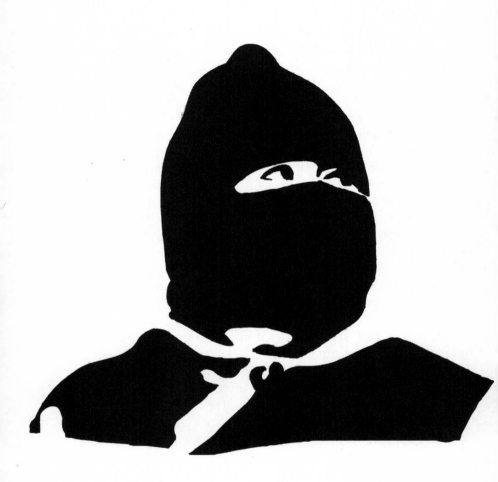

"The women finally understood that their participation is important if this bad situation is to change, and so they are participating, although not all of them are directly involved in the armed struggle. There is no other way of seeking justice, and this is the interest of the women." The demands of the women include childbirth clinics, daycare centres, corn-mills, training schools for women, and materials and support to create sustainable small businesses.

Ramona was diagnosed with cancer in 1994, and in 1995 she received a kidney transplant that extended her life for over a decade. Her last public appearance was at a preparation meeting for "The Other Campaign" aimed to form a united opposition to neoliberal capitalism through building organized resistance throughout Mexico.

"We want a Mexico that takes us into account as human beings, that respects us and that recognizes our dignity. Therefore we want to unite our small Zapatista voice with the large voice of all who fight for a new Mexico. We have come here in order to shout together that never more will there be a Mexico without us." At the end of her speech in Mexico City in 1996, the Zócalo resonated with chants of "Ramona, Ramona, Ramona, Ramona."

"Our hope is that one day our situation will change, that we women will be treated with respect, justice, and democracy."

PH●●LAN ●EVI
(1963–2001)

Phoolan Devi was an outlaw, women's right vigilante, prisoner, Indian parliamentarian, and legend in her own time. She was born in Uttar Pradesh, India, into the poverty of the Mallan caste—one of the lowest, the untouchables. She was married at thirteen to a middle aged man who beat and raped her. When she ran away from him, her mother told her to commit suicide. Phoolan didn't, and was ostracized by their village.

A few years later, a longstanding family dispute came to a head, and outspoken Phoolan was thrown in jail for her defiance and repeatedly gang raped by policemen, ostensibly to teach her subservience as expected of a woman of her status.

At sixteen, a gang of dacoits (bandits) abducted her and the gang's high-caste leader used her as his sex slave until Vikram Mallah, the low-caste deputy, killed him and took over the gang. Phoolan, whom he admired for her courage and spunk, married him, learned to shoot a rifle, and became his second-in-command. They looted, ransacked, and ransomed high-caste villages, sharing their spoils with the poor. Phoolan also went around exacting justice on all the men who had abused her.

When Vikram was assassinated by rivals, Phoolan was abducted by his assassins. They locked her up in Behmai, a village of high-caste Thakurs, who gang-raped her for three weeks until she managed to escape. She was soon leading a new gang. Her popularity was partly due to many considering her to be a reincarnation of Durga, the Hindu goddess of power. Almost two years later, she stumbled upon Behmai and planned to rob the village. When she recognized some of the men who had abused her, she ordered her gang to search the village for Vikram's killers. Unable to find them, they rounded up thirty men and opened fire, killing twenty-two of them.

The massacre triggered a massive police hunt to find her. Phoolan spent two years on the run, then negotiated a deal with the authorities and surrendered before ten thousand

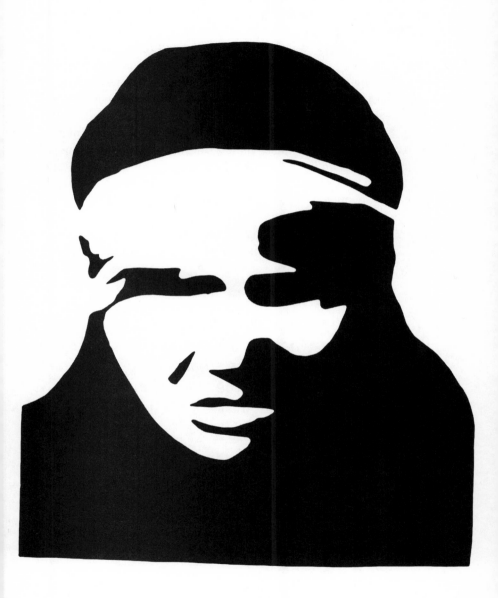

people. She was imprisoned without trial for eleven years. While under anaesthetic for an ovarian cyst operation, she was given a hysterectomy to prevent her from breeding.

In 1994, she was released and converted to Buddhism. The following year, the release of an unauthorised film about her life, *The Bandit Queen*, angered her, because it portrayed her as a victim. She threatened to set herself on fire if it wasn't withdrawn, but eventually settled for $60,000.

In 1996, she was elected to Parliament advocating women's and lower caste rights. During her campaign, she was vigorously heckled by the widows of Behmai who wanted to bring her to trial. Accusations were rife that her only real priority for becoming involved in politics was parliamentary immunity.

At the time of her death, she was still a divisive figure beloved of the lower castes and hated by the higher castes. She was shot dead outside her home in New Delhi at the age of thirty-seven.

"You can call it rape in your fancy language. Do you have any idea what it's like to live in a village in India? What you call rape, that kind of thing happens to poor women in the villages every day. It is assumed that the daughters of the poor are for the use of the rich."

MALALAI JOYA
(B. 1978)

Malalai Joya is an Afghani social activist, parliamentarian and promoter of women's and children's rights. She grew up in refugee camps in Iran and Pakistan after her family fled Afghanistan during the Soviet invasion in 1982. As a nineteen-year-old, she taught literacy classes to other Afghan women in Pakistan and then returned to Afghanistan in 1998 during the Taliban's reign. She worked as a social activist and was named a director of the Organisation for Promoting Afghan Women's Capabilities which ran an orphanage and a health clinic.

In 2003, she gained international attention as an elected delegate to the Loya Jirga who gave a fiery three-minute speech condemning the involvement of warlords in drafting the post-Taliban Afghan Constitution. Malalai was called "infidel" and "communist" and, by supporters, "the bravest woman in Afghanistan."

Two years later, she was elected to the lower house of the legislature, the Wolesi Jirga; at twenty-eight, she was the youngest member of parliament.

Since then, Malalai has accused Afghan officials of "trying to use the country's Islamic law as a tool with which to limit women's rights." She has also continued to publicly call for accountability for war crimes, even those perpetrated by fellow parliamentarians. Malalai also speaks openly about drug trafficking (90 percent of the world's opium supply is produced in Afghanistan) and systemic corruption. Malalai has been physically and verbally attacked by fellow members of parliament in session, received threats of rape, and has survived four assassination attempts. In response, she travels with armed guards, wears a burqa, and reportedly never spends two nights in the same place.

In May 2007, after comparing the Wolesi Jirga to "a stable of animals," Malalai was suspended from the parliament for three years for violating the prohibition on members of parliament from being openly critical of each other. People in Farah, the area she represents, as well as in other provinces of

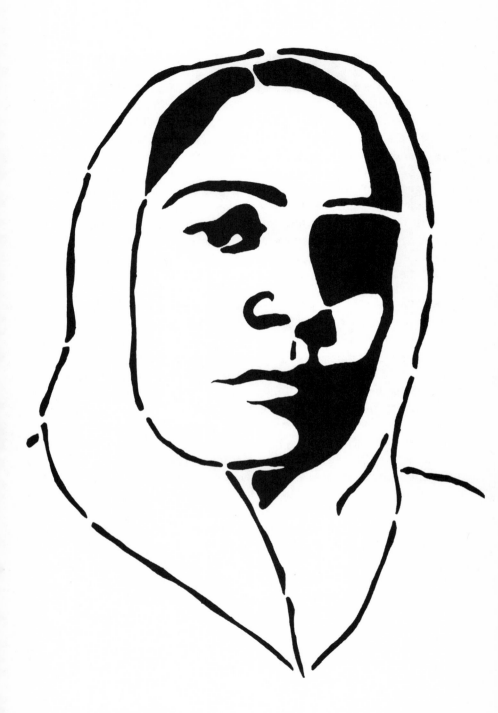

Afghanistan protested against her suspension, which is currently being appealed.

She has spoken in Australia, Canada, and Europe about women's and worker's rights, and the situation in Afghanistan. The United States, however, has not shown any sympathy, as Malalai has spoken out against the U.S. occupation and the mockery of its "war on terror." "No nation can donate liberation to another nation . . . The USA wants the things as they are. The status quo. A bleeding, suffering Afghanistan is a good excuse to prolong its stay. Now they are even embracing the Taliban." Her passport was confiscated in 2008.

Malalai Joya has received several international human rights awards and been the subject of a documentary, *Enemies of Happiness*.

"They will kill me but they will not kill my voice, because it will be the voice of all Afghan women. You can cut the flower, but you cannot stop the coming of spring."

"Never again will I whisper in the shadows of intimidation. I am but a symbol of my people's struggle and a servant to their cause. And if I were to be killed for what I believe in, then let my blood be the beacon for emancipation and my words a revolutionary paradigm for generations to come."

ACKNOWLEDGEMENTS

Queen of the Neighbourhood Collective would like to thank Carolyn Wilson, Bianca Scarlett, Peter Low, Ina Livingston, Theo Gordon, the Olive Morris Collective, Sara Minster, Joanne Quick, Lisa Benson, Fiona Jack, Karl Kersplebedeb, Lola Farquhar, Eve Gordon, Campbell Farquhar, Priscilla Penniket, Fans of the zine, Anarcha-feminists of Aotearoa, Awesome Grrrlz Gang, Infoshops, Queens, Posties, Mums, Rabbit cats, Mushroom house squatters, Stanley knife makers, Sharpie sharpeners, Dumpster deities, everyone who ever came into Cherry Bomb Comics 2004–2007, and all the inspirational revolutionary women in this book.

GLOSSARY

Algerian National Liberation Front (FLN): A nationalist political party founded in 1954 to work for Algerian independence from France. Although originally socialist-leaning, it is now pro-market and widely considered pro–status quo in Algeria.

Alter-globalization Movement: A social movement that supports global cooperation and interaction but opposes what it perceives as the negative effects of globalization, such as failure to promote environmental protection, economic justice, and the protection of indigenous cultures and human rights.

American Indian Movement (AIM): A Native American activist organization founded in 1968. Its activities include protests on relevant issues, support of cultural renewal, and employment programs.

American Union Against Militarism: A pacifist organization active during World War I.

Anarcha-feminism: A philosophy defining anarchist struggle as a necessary component of feminist struggle and vice versa, emphasizing that the struggle against patriarchy is an essential part of the struggle against capitalism and the state.

Arab Nationalist Movement: A socialist and secularist Pan-Arab nationalist movement of the late 1950s and 1960s aimed at creating a revolution in Arab consciousness and the resulting social change.

Batista Dictatorship: Rule of Cuba by former president Fulgencio Batista after coming to power in a military coup in 1952. Batista was overthrown by guerilla forces led by Fidel Castro in 1959.

Battle of Algiers: The FLN's 1956–1957 campaign of guerilla warfare against the French.

Black Liberation Army: An underground Black nationalist organization active between 1971 and 1981 with the goal of revolutionary change in the American system and "taking up arms for liberation and self-determination of Black people in the United States."

Black Panther Party: A socialist-influenced organization formed in 1966 as part of the American Black Power Movement, particularly dedicated to self-defense and "survival projects."

Boston marriage: A late-nineteenth century term used to describe a longterm monogamous relationship between two unmarried women, or an arrangement in which two women lived together independent of any man's support.

Carmichael, Stokely (1941–1998) (later known as Kwame Ture): American Civil Rights and Black Power activist.

Chinese Revolutionary Alliance: An underground alliance of Chinese revolutionary groups formed in 1905 "to expel the northern barbarians [the Manchu people] and to revive Zhonghua [Chinese civilization], and to distribute land equally among the people."

Cultural Revolution: A political campaign launched in 1966 by Mao Zedong to eliminate his political rivals and to effect a revolutionary cleansing of the "bourgeois" influences and values which remained in Chinese society. The result was widespread social and political chaos, the deaths of thousands, and the imprisonment or exile of millions more.

Gay Activists Alliance (GAA): A nonviolent "single-issue, politically-neutral militant organization" founded in 1969 to "secure basic human rights, dignity and freedom for all gay people." It existed until 1981.

Gay Liberation Front: A loose coalition of a number of Gay Liberation groups in United States and England, the first of which was formed in New York City as a response to the Stonewall Riots. Active from 1969–1972, it took action to end anti-gay prejudices, in addition to advancing more wide-ranging social criticism, such as antiracism and opposition to the nuclear family.

Industrial Workers of the World (also known as the Wobblies): An international labor union founded and headquartered in the United States. IWW strives for the union of all industrial workers and an end to the profit system.

International Forum on Globalization: An alliance formed to stimulate new thinking, joint activity, and public education in response to economic globalization and its impact.

International Working People's Association: An American anarchist labor organization that advocated radical direct action and took a leading role in the campaign for the eight-hour day.

Irish Citizen Army (ICA): A workers defense militia established in Dublin in 1913 and evolved into a revolutionary organization dedicated to the creation of an Irish socialist republic. Participated in the Easter Rising of 1916 to end British rule, in the Irish War of Independence (1919–1921) and the Irish Civil War (1922–1923).

Irish Republican Army (IRA): Army of the Irish Republic of 1919, waging a guerilla campaign against the British in the Irish War of Independence. Conflict over the Anglo-Irish Treaty of 1921 within its ranks led to the Irish Civil War.

Iskra: Meaning "spark" in Russian. The official newspaper of the Russian Social Democratic Labour Party.

Jackson, George (1941–1971): American communist activist and Black Panther Party member.

Jogiches, Leo (1867–1919): Lithuanian Marxist revolutionary, active in Poland and Germany. A founding member of the Polish Social Democratic Party and the Spartacus League.

Knights of Labor (also known as Noble and Holy Order of the Knights of Labor): A broad-based nineteenth-century American labor organization aimed at creating cooperative institutions of production and distribution.

Kropotkin, Peter (1842–1921): Russian anarchist theorist and activist.

Land and Liberty: A Russian revolutionary group of the 1870s committed to spreading socialism in rural areas.

Liebknecht, Karl (1871–1919): German Marxist revolutionary, founding member of the Spartacus League and the Communist Party of Germany.

Loya Jirga: Grand Council. An Afghan political meeting to settle intertribal disputes, discuss social reforms, and approve a new constitution.

Marcuse, Herbert (1898–1979): German-born Marxist social theorist.

May Day: May 1, International Workers' Day.

Milk Bar Bombing: One of three bombs planted in civilian locations on September 30, 1956, by female militants of the FLN, which launched the Battle of Algiers.

Miscegenation laws: Laws forbidding marriage between white people and members of other races.

Gamal Abdel Nasser (1917–1970): President of Egypt from 1956 until his death.

National Alliance Against Racism and Political Repression: An American political group founded in 1973 to organize action on behalf of individuals treated unjustly because of their race or political opinions.

Nechaev, Sergei (1847–1882): Activist in the Russian Nihilist Movement of the 1870s; author of the influential *Catechism of the Revolutionist.*

Organization of Promoting Afghan Women's Capabilities (OPAWC): A nongovernmental organization active in healthcare, education and income-generating projects.

The Other Campaign: A political program launched by the EZLN in 2006 to create a united front of opposition to capitalism and neoliberalism.

Palestinian National Council: The legislative body of the Palestinian Liberation Organization.

Popular Front for the Liberation of Palestine (PFLP): A political party and paramilitary organization founded in 1967. Second largest group in the Palestine Liberation Organization, with nationalist, socialist, and secular politics.

Puerto Rican Nationalist Party: A party formed in 1922 with the objective of working for Puerto Rican Independence.

Ravensbrück: A World War II women's concentration camp in Northern Germany.

Republic of New Afrika: A social movement calling for the creation of an independent Black state in the American south and for reparations from the American government.

Russian Social Democratic Labour Party: A revolutionary Marxist party founded in 1898. A 1903 doctrinal split led to creation of two factions: the *Bolsheviks* (majority) led by Vladimir Ilich Lenin and the *Mensheviks* (minority) led by Julius Martov. The Bolsheviks would go on to become the Communist Party of the Soviet Union and in that capacity were able to eliminate their Menshevik rivals.

Sinn Féin: A left-wing Irish Republican Party.

Slovenian Liberation Front: A World War II resistance group fighting against Germany and Italy.

Spanish Civil War (1936–1939): A conflict that began with the uprising of Spanish Army generals against the Second Spanish Republic and concluded with the nationalists' victory, the overthrow of the Republic, and the beginning of the long dictatorship of General Francisco Franco.

Spanish National Confederation of Labour: An anarcho-syndicalist federation of workers and peasant unions formed in 1911 and existing until the defeat of the Republic in the Spanish Civil War. It aimed for the overthrow of the state and capitalism and the creation of an anarchist society.

Spartacus Uprising: A general strike in Berlin from January 5–12, 1919. Its violent suppression marked the end of the German Revolution.

Student Nonviolent Coordinating Committee (SNCC): An American Civil Rights Movement organization formed in 1960 at Shaw University in Raleigh, North Carolina, and spread across the country. SNCC was particularly involved in sit-ins, freedom rides and voter registration drives.

Sun Yat-sen (ca. 1870–1925): Leader of the revolutionary movement to overthrow the Qing dynasty and first president of the Republic of the China in 1912. Often referred to as "The Father of Modern China."

Trail of Broken Treaties: A cross-country protest by Native American and First Nation organizations in 1972 to highlight Native American issues such as treaty rights, living standards, and inadequate housing. The protest culminated in the occupation of the Bureau of Indian Affairs building in Washington D.C.

26th of July Movement: The revolutionary organization led by Fidel Castro to overthrow the government of Fulgencio Batista in Cuba. After victory, the group joined with others to become the United Party of the Cuban Socialist Revolution and, after 1965, the Communist Party of Cuba.

Underground Railroad: A network of secret routes and safe-houses used by African American slaves to escape to Northern states and to Canada.

United Farm Workers of America: A group founded in 1962 to organize agricultural workers in the United States.

Wolesi Jirga: The House of the People. The lower house of the National Assembly of Afghanistan.

Yacef, Saadi (b. 1928): Leader of the FLN during the Algerian War of Independence; now an Algerian senator.

Zapatista Army for National Liberation (EZLN): An armed revolutionary group which since 1994 has declared war on the Mexican state. With a strong indigenous base, EZLN calls for indigenous control over local resources, and stands for social movements opposed to globalization and neoliberalism.

RESOURCE LIST

A short list of sites/books dedicated to portraiture of radicals:

http://www.imow.org/wpp/stories/viewStory?storyid=1407
http://leftistlounge.com/Art/woman%20canvas/index.html
http://www.favianna.com/port_other/other1.php
http://www.justseeds.org/artists/
http://infoshop.org/page/Anarcha-feminism
http://www.artsenliberte.com/php/index.php?option=com_content&
 task=view&id=37&Itemid=43
http://cake3.home.mindspring.com/feminino_page.htm
Waugh, Nicole and Jay Moreno. *The Color Of Dissent: Book One.*
 Coloring For A Cause, 2006.

HARRIET TUBMAN

http://en.wikipedia.org/wiki/Harriet_Tubman.
Clinton, Catherine. *Harriet Tubman: The Road to Freedom.* Boston:
 Little, Brown and Company, 2004.
Humez, Jean M. *Harriet Tubman: The Life and Life Stories.* Madison:
 The University of Wisconsin Press, 2003.
Jones, David E. *Women Warriors: A History.* Washington: Brassey's
 Ltd, 1997 (reprint 2005).
Lee, Butch. *Jailbreak out of History: The Re-biography of Harriet
 Tubman.* Montreal: Kersplebedeb, 2003.

LOUISE MICHEL

http://www.iisg.nl/collections/louisemichel/biography.php.
http://en.wikipedia.org/wiki/Louise_Michel.
Maclellan, Nic, ed. *Louise Michel.* Rebel Lives Series. Melbourne:
 Ocean Press, 2004.
Michel, Louise. *The Memoirs of Louise Michel, the Red Virgin.*
 University of Alabama Press, 1981.
Thomas, Edith. *Louise Michel.* Montreal: Black Rose Books, 1980.

MOTHER JONES

Broderick, Marian. *Wild Irish Women: Extraordinary Lives from History.*
 Dublin: O'Brien, 2001.
Gannon, Joseph E. "Mary Harris Jones: One Tough 'Mother'." http://
 thewildgeese.com/pages/mojones.html.
Gorn, Elliot. *Mother Jones: The Most Dangerous Woman in America.*

New York: Hill and Wang, 2001.

Gorn, Elliot. "Mother Jones: The Woman." Mother Jones. http://www.motherjones.com/politics/2001/05/mother-jones-woman.

VERA ZASULICH

http://www.marxists.org/archive/Zasulich/index.htm.

http://en.wikipedia.org/wiki/Vera_Zasulich.

http://www.spartacus.schoolnet.co.uk/RUSzasulich.htm.

Bergman, Jay. *Vera Zasulich : A Biography*. Stanford, CA: Stanford University Press, 1983.

Silijak, Ana. *Angel of Vengeance: The "Girl Assassin," The Governor of St. Petersburg, and Russia's Revolutionary World*. New York: St Martin's Press, 2008.

LUCY PARSONS

Ashbaugh, Carolyn. *Lucy Parsons: American Revolutionary*. Chicago: Charles H. Kerr Publishing Company, 1976.

Flood, Andrew. "Rescuing Lucy Parsons for the Anarchist Movement." http://www.struggle.ws/andrew/people/LucyParsons.html?story_id=426.

http://www.lucyparsons.org.

http://www.lucyparsonsproject.org.

McKean, Jacob. "A Fury for Justice: Lucy Parsons and the Revolutionary Anarchist Movement in Chicago." http://www.wcote.org/~roadrunner/ScarlettLetterArchives/LucyParsons/FuryforJustice.htm

Parsons, Lucy. *Lucy Parsons: Freedom, Equality & Solidarity: Writings and Speeches, 1878–1937*. Chicago: Charles H. Kerr Publishing Company, 2003.

Roediger, Dave and Franklin Rosemont, eds. *Haymarket Scrapbook*. Chicago: Charles H. Kerr Publishing Company, 1986.

EMMA GOLDMAN

Falk, Candace Serena. *Love, Anarchy, and Emma Goldman*. New Brunswick: Rutgers University Press, 1990.

Goldman, Emma. *Living My Life*. 2 vols. New York: Pluto Books, 1987.

Rudahl, Sharon. *A Dangerous Woman: The Graphic Biography of Emma Goldman*. New York: The New Press, 2007.

Wexler, Alice. *Emma Goldman: An Intimate Life*. New York: Pantheon Books, 1984.

_____. *Emma Goldman in Exile: From the Russian Revolution to the*

Spanish Civil War. Boston: Beacon Press, 1989.
http://en.wikipedia.org/wiki/Emma_Goldman.

ROSA LUXEMBURG

http://www.spartacus.schoolnet.co.uk/RUSluxemburg.htm.
http://www.rosalux.de/cms/index.php?id=4551.
http://www.spiegel.de/international/germany/0,1518,601475,00.html.
http://www.cddc.vt.edu/feminism/Luxemburg.html.
Ettinger, Elzbieta. *Rosa Luxemburg: A Life*. Boston: Beacon Press, 1986.
Luxemburg, Rosa. *The Rosa Luxemburg Reader*. New York: Monthly Review Press, 2004.
———. *The Letters of Rosa Luxemburg*. Atlantic Highlands, NJ: Humanities Press, 1993.
Nettl, J. P. *Rosa Luxemburg*. 2 vols. London: Oxford University Press, 1966.

MARIE EQUI

http://bitter.custard.org/intimate/fling/equi.htm.
http://www.nlm.nih.gov/changingthefaceofmedicine/physicians/biography_103.html.
http://www.glapn.org/605equi.html.
http://www.ohs.org/education/oregonhistory/historical_records/dspDocument.cfm?doc_ID=000B3F93-20D8-1E30-925B80B05272006C.
Friedman, Ralph. *The Other Side of Oregon*. Caldwell, ID: Caxton Press, 1993.
Krieger, Nancy. *Queen of the Bolsheviks: The Hidden History of Dr. Marie Equi*. Montreal: Kersplebedeb, 2009.

QIU JIN

http://en.wikipedia.org/wiki/Qiu_Jin.
http://www.distinguishedwomen.com/biographies/qiujin.html.
http://everything2.com/title/Qiu%2520Jin.
http://www.suppressedhistories.net/articles/qiujin.html.
Lee, Butch. *The Military Strategy of Women and Children*. Montreal: Kersplebedeb, 2003.

NORA CONNOLLY O'BRIEN

http://searcs-web.com/obrien.html.
http://irelandsown.net/Nora.htm.

O'Brien, Nora Connolly. *We Shall Rise Again*. London: Mosquito Press, 1981.

LUCÍA SÁNCHEZ SAORNIL

http://www.segundarepublica.com/index.php?opcion=2&id=46.

http://www.asociacionconvive.com/index.php?option=com_content&view=article&id=373:lucia-sanchez-saornil&catid=35:escritoras&Itemid=11.

http://www.recollectionbooks.com/cs/spain/SaornilQuestionOf Feminism.doc.

Ackelsburg, Martha A. *Free Women of Spain: Anarchism and the Struggle for the Emancipation of Women*. Bloomington: Indiana University Press, 1991.

Nash, Mary. *Defying Male Civilization: Women in the Spanish Civil War*. Denver: Arden Press, 1995.

DAME WHINA COOPER

http://www.nzgirl.co.nz/articles/6387.

http://www.nzhistory.net.nz/people/dame-whina-cooper.

http://www.dnzb.govt.nz/dnzb/alt_essayBody.asp?essayID=5C32.

King, Michael. *Whina: A Biography of Whina Cooper*. Auckland: Penguin Books, 1991.

DORIA SHAFIK

Hannam, June, Mitizi Auchterlonie and Katherine Holden. *International Encyclopedia of Women's Suffrage*. Santa Barbara, Ca.: ABC-CLIO, 2000.

Hassan, Fayza. "Speaking for the Other Half." http://weekly.ahram.org.eg/2001/523/sc3.htm.

Keddie, Nikki R. and Beth Baron, eds. *Women in Middle Eastern History: Shifting Boundaries in Sex and Gender*. New Haven: Yale University Press, 1991.

Nelson, Cynthia. *Doria Shafik, Egyptian Feminist: A Woman Apart*. Gainesville, FL.: University Press of Florida, 1996.

Sullivan, Earl L. *Women in Egyptian Public Life*. Syracuse, NY: Syracuse University Press, 1986.

LOLITA LEBRÓN

http://en.wikipedia.org/wiki/Lolita_Lebron.

http://www.september23.org/.

http://www.yasminhernandez.com/lolitastory.html.

http://boricuahumanrights.org/.
Cook, Bernard A. *Women and War: A Historical Encyclopedia from Antiquity to the Present.* Santa Barbara, CA: ABC-CLIO, 2006.

HANNIE SCHAFT
http://en.wikipedia.org/wiki/Hannie_Schaft.
http://www.hannieschaft.nl/25eng.html.
http://www.bevrijdingintercultereel.nl/eng/nederland.html.
Menger-Oversteegen, Truus. *Not Then, Not Now, Not Ever.* Amsterdam: Netherland Tolerant, 1998.
Strobl, Ingrid. *Partisans: Women in the Armed Resistance to Fascism and German Occupation (1936–1945).* Edinburgh: AK Press, 2008.

HAYDÉE SANTAMARÍA CUADRADO
http://es.wikipedia.org/wiki/Hayd%C3%A9e_Santamar%C3%ADa_Cuadrado.
http://www.marxist.com/History-old/who_is_celia_hart.html.
http://celiasanchez.org/
Maclean, Betsy, ed. *Haydée Santamaría.* Rebel Lives Series. Melbourne: Ocean Press, 2003.
Santamaría, Haydée. *Moncada, Memories of the Attack that Launched the Cuban Revolution.* Secaucus, NJ: L. Sharp, 1980.
Stone, Elizabeth. *Women and the Cuban Revolution.* New York: Pathfinder Press, 1982.

ONDINA PETEANI
http://www.atuttascuola.it/ondina.
http://www.lager.it/ondina_peteani.html.
http://www.geocities.com/ondinapeteani/Ondina-Petani.html.
http://www.olkaustos.org.saggi/saggi/peteani/.

ANI PACHEN
http://en.wikipedia.org/wiki/Ani_Pachen.
http://www.shambhalasun.com/index.php?option=com_content&task=view&id=1771.
Pachen, Ani & Adelaide Donnelley. *Sorrow Mountain: The Journey of a Tibetan Warrior Nun.* London: Doubleday, 2000.

DJAMILA BOUHIRED
http://en.wikipedia.org/wiki/Djamila_Bouhired.

http://www.time.com/time/magazine/article/0,9171,863146,00.html.
http://www.alshindagah.com/novdec03/womanofdistinction.html.
Chahine, Youssef. *Jamila the Algerian* (Film). Egypt, 1958.
Charrad, Mounira M. *States and Women's Rights: The Making of
 Postcolonial Tunisia, Algeria, and Morocco.* Berkeley:
 University of California Press, 2001.
Lazreg, Marnia. *The Eloquence of Silence: Algerian Women in Question.*
 New York: Routledge Press, 1994.

ANGELA DAVIS

http://en.wikipedia.org/wiki/Angela_Davis.
http://historicalbiographies.suite101.com/article.cfm/the-rapture-of-
 angela-davis.
http://www.fembio.org/english/biography.php/woman/biography/
 angela-davis/.
http://socialjustice.ccnmtl.columbia.edu/index.php/Angela_Davis.
Davis, Angela Y. *Angela Davis: An Autobiography.* New York:
 International Publishers, 1974.

LEILA KHALED

http://en.wikipedia.org/wiki/Leila_Khaled.
http://www.answers.com/topic/leila-khaled.
Khaled, Leila, and Hajjar, George. *My People Shall Live: Autobiography
 of a Revolutionary.* Toronto: NC Press, 1975.
MacDonald, Eileen. *Shoot the Women First.* New York: Random
 House, 1991.
Makboul, Lina. *Leila Khaled, Hijacker.* Sweden: Tussilago and Sveriges
 Television, 2005.

ANNA MAE AQUASH

http://en.wikipedia.org/wiki/Anna_Mae_Aqaush.
http://dickshovel.com/annalay.html.
Brand, Johanna. *The Life and Death of Anna Mae Aquash.* Toronto:
 James Lorimer & Company, 1993.
Forster, Merna. *100 Canadian Heroines: Famous and Forgotten Faces.*
 Toronto: Dundurn Press, 2004.
James, Edward T., Barbara Sicherman, Janet Wilson James, Paul S.
 Boyer, and Susan Ware. *Notable American Women: A
 Bibliographical Dictionary.* Cambridge, MA: Harvard University
 Press, 2004.
Mihesuah, Devon Abbott. *Indigenous American Women: Decolonization,*

Empowerment, Activism. Lincoln: University of Nebraska Press, 2003.

ASSATA SHAKUR
http://en.wikipedia.org/wiki/Assata_Shakur.
http://www.assatashakur.org/.
http://afrocubaweb.com/assata.htm.
http://www.itsabouttimebpp.com/Assata_Shakur/Assata_Shakur_index.html.
Shakur, Assata. *Assata: An Autobiography.* Westport, Conn: Lawrence Hill & Co., 1987.

BRIGITTE MOHNHAUPT
http://en.wikipedia.org/wiki/Brigitte_Mohnhaupt.
http://www.timesonline.co.uk/tol/news/world/europe/aritcle156065.ece.
http://news.bbc.co.uk/1/hi/world/europe/6352903.
http://www.guardian.co.uk/world/2007/feb/12/germany.
Smith, J & André Moncourt. *Daring To Struggle, Failing to Win: The Red Army Faction's 1977 Campaign Of Desperation.* Oakland, CA: PM Press, 2008.

SYLVIA RIVERA
http://www.sylviasplace.org/.
http://en.wikipedia.org/wiki/Sylvia_Rivera.
http://www.ifge.org/Article52.phtml.
http://soundportraits.org/in-print/magazine_articles/sylvia_rivera/.
http://srlp.org/about.
http://www.workers.org/ww/1998/sylvia0702.php.
http://www.glbtq.com/social-sciences/rivera_s.html.

OLIVE MORRIS
http://rememberolivemorris.wordpress.com/.
http://www.africanafrican.com/negroartist/OLIVE%20MORRIS/OLIVE%20MORRIS.htm.

VANDANA SHIVA
http://en.wikipedia.org/wiki/Vandana_Shiva.
http://www.navdanya.org/.
Mies, Maria and Vandana Shiva. *Ecofeminism.* Halifax, NS: Fernwood Publications, 1993.

Shiva, Vandana. *Stolen Harvest: The Hijacking of the Global Food Supply.* Cambridge, MA: South End Press, 2000.

_____. *Earth Democracy: Justice, Sustainability and Peace.* Cambridge, MA: South End Press, 2005.

Wheat, Sue. "Vandana Shiva: Environmental Activist – India." *New Internationalist* 268 (June 1995).

COMANDANTE RAMONA

http://www.jornada.unam.mx/2006/01/13/index.php?section=opinion &article=021a1pol.

http://es.wikipedia.org/wiki/Comandanta_Ramona.

http://www.imow.org/wpp/stories/viewStory?storyId=1407.

http://flag.blackened.net/revolt/mexico/ezln/1997/romana_at_uni_mar.html.

Perez U., Mathilde and Castellanos, Laura. "Do Not Leave Us Alone! Interview with Comandante Ramona." *Double Jornada*, March 7, 1994.

Reader, Sarah. *Caminando Preguntamos: Women and the Zapatista Movement,* blogs.warwick.ac.uk/dissidentwarwick, 2009.

PHOOLAN DEVI

http://people.virginia.edu/~pm9k/gifs/ZoForth/Pholan/folanBib.html.

http://en.wikipedia.org/wiki/Phoolan_Devi.

Devi, Phoolan, Marie-Thérèse Cuny and Paul Rambali. *I, Phoolan Devi: The Autobiography of India's Bandit Queen.* London: Little, Brown and Co, 1996.

Sen, Mala. *India's Bandit Queen: The True Story of Phoolan Devi.* London: Pandora, 1993.

Shears, Richard and Isobelle Gidley. *Devi: The Bandit Queen.* London: Allen & Unwin, 1984.

MALALAI JOYA

http://en.wikipedia.org/wiki/Malalai_Joya.

http://www.malalaijoya.com/index1024.htm.

Joya, Malalai. *Raising my Voice: the Extraordinary Story of the Afghan Woman who Dares to Speak Out.* London: Rider, 2009.

Lichter, Ida. *Muslim Women Reformers: Inspiring Voices Against Oppression.* Amherst, NY: Prometheus Books, 2009.

Mulvad, Eva. *Enemies of Happiness.* Denmark: Bastard Film, 2006

ABOUT THE AUTHORS

Queen of the Neighbourhood Collective is an all-women crew of writers, researchers, editors and artists originally hailing from Aotearoa/NZ. They are Tui Gordon, Hoyden, Melissa Steiner, Anna Kelliher, Rachel Bell, Anna-Claire Hunter, and Janet McAllister, plus a few assorted comrades and accomplices. Taking seed from the original zine, *Revolutionary Women Stencil Book*, the collective sprouted up from fans and friends who spent the next two years distilling their feminist passion into this self-help book for the herstorically bereft, reading, writing, trawling the internet, and cutting stencils on the kitchen table. Drawing on backgrounds from disparate worlds in zine-making, art, activism and academia, this is Queen of the Neighbourhood's first book.

Tui, based in Tamaki Makaurau/Auckland, has written zines *Para Ser de la Tierra*, *Sphagnum Girl*, *Revolutionary Women Stencil Book* and *Scratch & Sniff*. She also runs Cherry Bomb Comics, a feminist comic book store & zine distro, with Melissa.

Hoyden squats in South London, where she is a volunteer at 56a Infoshop and is part of the Scumfest collective.

Melissa lives in North London and writes blog Slow Songs for Fast Hearts. Her zine is *Adventures Close to Home*. She runs Cherry Bomb Comics, a feminist comic book store & zine distro with Tui.

Anna is based in Christchurch, NZ, where she studies history and religion.

Rachel is an artist/maker who lives in rural Aotearoa/New Zealand. When she is not working on her Masters in Design she can be found digging in the garden, making soap and knitting her heart out.

Anna-Claire lives in Otautahi/Christchurch. She is a radical feminist and stencil artist. She aspires to live every moment consciously and to decolonize her mind through challenging privilege (including her own).

Janet reads, writes, and edits nonfiction in Auckland.

"When she walks, the revolution's coming." ("Rebel Girl," Bikini Kill)

32 POSTCARDS BY ERIC DROOKER

SLINGSHOT:
32 POSTCARDS
Eric Drooker

978-1-60486-016-0

$14.95

Disguised as a book of innocent postcards, *Slingshot* is a dangerous collection of Eric Drooker's most notorious posters. Plastered on brick walls from New York to Berlin, tattooed on bodies from Kansas to Mexico City, Drooker's graphics continue to infiltrate and inflame the body politic. Drooker is the author of two graphic novels, *Flood! A Novel in Pictures* (winner of the American Book Award), and *Blood Song: A Silent Ballad*. He collaborated with Beat poet Allen Ginsberg on the underground classic, *Illuminated Poems*. His provocative art has appeared on countless posters, book and CD covers, and his hard-edged graphics are a familiar sight on street corners throughout the world. Eric Drooker is a third generation New Yorker, born and raised on Manhattan Island. His paintings are frequently seen on covers of *The New Yorker* magazine, and hang in various art collections throughout the U.S. and Europe.

Praise:

"Drooker's old Poe hallucinations of beauteous deathly reality transcend political hang-up and fix our present American dreams."
 —Allen Ginsberg

"When the rush of war parades are over, a simple and elegant reminder of humanity remains—in the work of Eric Drooker."
 —Sue Coe

SIGNAL:01
A JOURNAL OF INTERNATIONAL POLITICAL GRAPHICS AND CULTURE
Alec Dunn & Josh MacPhee, eds.

978-1-60486-091-7

$14.95

Signal is an ongoing book series dedicated to documenting and sharing compelling graphics, art projects, and cultural movements of international resistance and liberation struggles. Artists and cultural workers have been at the center of upheavals and revolts the world over, from the painters and poets in the Paris Commune to the poster makers and street theatre performers of the recent counter globalization movement. *Signal* will bring these artists and their work to a new audience, digging deep through our common history to unearth their images and stories. We have no doubt that Signal will come to serve as a unique and irreplaceable resource for activist artists and academic researchers, as well as an active forum for critique of the role of art in revolution.

In the U.S. there is a tendency to focus only on the artworks produced within our shores or from English speaking producers. *Signal* reaches beyond those bounds, bringing material produced the world over, translated from dozens of languages and collected from both the present and decades past. Although a full color printed publication, *Signal* is not limited to the graphic arts. Within its pages you will find political posters and fine arts, comics and murals, street art, site specific works, zines, art collectives, documentation of performance and articles on the often overlooked but essential role all of these have played in struggles around the world.

Signal:01 includes:

* The Future of Xicana Printmaking: Alec Dunn and Josh MacPhee
 interview the Taller Tupac Amaru
* The Adventures of Red Rat: Alec Dunn interviews Johannes van de Weert
* Hard Travelin': A photo essay with IMPEACH
* Early 20th-Century Anarchist Imprints
* Mexico 68: The Graphic Production of a Movement: Santiago Armengod
 interviews Felipe Hernandez Moreno
* Adventure Playgrounds: A photo essay
* Designing Anarchy: Dan Poyner interviews Rufus Segar

PAPER POLITICS: SOCIALLY ENGAGED PRINTMAKING TODAY

Josh MacPhee, ed.

978-1-60486-090-0

$24.95

Paper Politics: Socially Engaged Printmaking Today is a major collection of contemporary politically and socially engaged printmaking. This full color book showcases print art that uses themes of social justice and global equity to engage community members in political conversation. Based on an art exhibition which has traveled to a dozen cities in North America, *Paper Politics* features artwork by over 200 international artists; an eclectic collection of work by both activist and non-activist printmakers who have felt the need to respond to the monumental trends and events of our times.

Paper Politics presents a breathtaking tour of the many modalities of printing by hand: relief, intaglio, lithography, serigraph, collagraph, monotype, and photography. In addition to these techniques, included are more traditional media used to convey political thought, finely crafted stencils and silk-screens intended for wheat pasting in the street. Artists range from the well established (Sue Coe, Swoon, Carlos Cortez) to the up-and-coming (Favianna Rodriguez, Chris Stain, Nicole Schulman), from street artists (BORF, You Are Beautiful) to rock poster makers (EMEK, Bughouse).

Praise:

"Let's face it, most collections of activist art suck. Either esthetic concerns are front and center and the politics that motivate such creation are pushed to the margin, or politics prevail and artistic quality is an afterthought. With the heart of an activist and the eye of an artist, Josh MacPhee miraculously manages to do justice to both. *Paper Politics* is singularly impressive." —Stephen Duncombe, author of *Dream: Re-Imagining Progressive Politics in an Age of Fantasy*

FRIENDS OF

These are indisputably momentous times—the financial system is melting down globally and the Empire is stumbling. Now more than ever there is a vital need for radical ideas.

In the three years since its founding—and on a mere shoestring—PM Press has risen to the formidable challenge of publishing and distributing knowledge and entertainment for the struggles ahead. With over 100 releases to date, we have published an impressive and stimulating array of literature, art, music, politics, and culture. Using every available medium, we've succeeded in connecting those hungry for ideas and information to those putting them into practice.

Friends of PM allows you to directly help impact, amplify, and revitalize the discourse and actions of radical writers, filmmakers, and artists. It provides us with a stable foundation from which we can build upon our early successes and provides a much-needed subsidy for the materials that can't necessarily pay their own way. You can help make that happen – and receive every new title automatically delivered to your door once a month – by joining as a Friend of PM Press. And, we'll throw in a free T-Shirt when you sign up.

Here are your options:

• $25 a month: Get all books and pamphlets plus 50% discount on all webstore purchases.
• $25 a month: Get all CDs and DVDs plus 50% discount on all webstore purchases.
• $40 a month: Get all PM Press releases plus 50% discount on all webstore purchases
• $100 a month: Sustainer. - Everything plus PM merchandise, free downloads, and 50% discount on all webstore purchases.

For those who can't afford $25 or more a month, we're introducing Sustainer Rates at $15, $10 and $5. Sustainers get a free PM Press t-shirt and a 50% discount on all purchases from our website.

Just go to **WWW.PMPRESS.ORG** to sign up. Your Visa or Mastercard will be billed once a month, until you tell us to stop. Or until our efforts succeed in bringing the revolution around. Or the financial meltdown of Capital makes plastic redundant. Whichever comes first.

 PM Press was founded at the end of 2007 by a small collection of folks with decades of publishing, media, and organizing experience. PM Press co-conspirators have published and distributed hundreds of books, pamphlets, CDs, and DVDs. Members of PM have founded enduring book fairs, spearheaded victorious tenant organizing campaigns, and worked closely with bookstores, academic conferences, and even rock bands to deliver political and challenging ideas to all walks of life. We're old enough to know what we're doing and young enough to know what's at stake.

We seek to create radical and stimulating fiction and non-fiction books, pamphlets, t-shirts, visual and audio materials to entertain, educate and inspire you. We aim to distribute these through every available channel with every available technology—whether that means you are seeing anarchist classics at our bookfair stalls; reading our latest vegan cookbook at the café; downloading geeky fiction e-books; or digging new music and timely videos from our website.

PM Press is always on the lookout for talented and skilled volunteers, artists, activists and writers to work with. If you have a great idea for a project or can contribute in some way, please get in touch.

PM Press
PO Box 23912
Oakland CA 94623
510-658-3906
www.pmpress.org